1

Christina Quarles *Collapsed Time*

Nationalgalerie
Staatliche Museen zu Berlin

Für die / For the **Nationalgalerie**
– Staatliche Museen zu Berlin
herausgegeben von / edited by
Sam Bardaouil & Till Fellrath

*Nationalgalerie
der Gegenwart*

**Hamburger
Bahnhof**

SilvanaEditoriale

Inhalt
/ *Content*

Christina Quarles.
Collapsed Time

Sam Bardaouil
& Till Fellrath

Über das Werk von Christina Quarles gäbe es so viel zu sagen, so viele Schichten ließen sich freilegen, so viele Anspielungen herausstellen, so viele formale Strukturen untersuchen und Identitätsmarker erkunden. Der gewaltige Reichtum des Œuvres dieser aufsteigenden Künstlerin geht weit über das Gewöhnliche hinaus.

Man nehme nur Quarles' zentrales Thema, den Akt. Sie dehnt nicht nur die formalen Grenzen dessen aus, was vielleicht – zumindest innerhalb der sogenannten Westlichen Kunstgeschichte – eines der am längsten etablierten Genres der Malerei ist. Quarles' Umgang mit der menschlichen Gestalt geht über das Verschmelzen von Körperteilen, so faszinierend und bedrohlich es auch sein mag, hinaus, um einen Weg in die gelebte Erfahrung eines rassifizierten, queeren Körpers zu bahnen. Dass Quarles Tochter eines Schwarzen Vaters und einer *weißen* Mutter ist, wird, ihrer vergleichs-

There is so much one can write about the work of Christina Quarles: so many layers to unpeel, so many allusions embedded in the work to highlight, formal traits to scrutinize, and identity markers to delve into. The powerful richness of this rising artist's work is by no means ordinary.

Take Quarles's recurring subject, the nude. Besides expanding the formal boundaries of what is perhaps one of the longest standing genres of painting, at least within the scope of so-called Western Art History, Quarles's treatment of the human form transcends the amalgamation of body parts, as fascinating and menacing as they may be, in order to become a gateway into the lived experience of a racialized, queer body. The daughter of a Black father and a white mother, Quarles's multi-racial background is often not recognized by others, her relatively fair skin obscuring her "multiply situated racial identity."[1] Consequently, her representations are not reproductions of

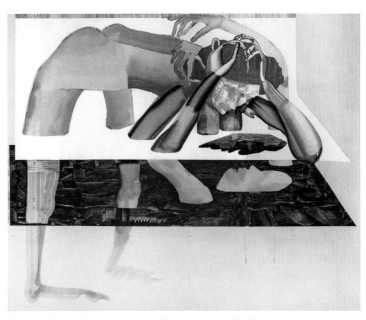

Christina Quarles, *Double Down*, 2017, 121,9 x 152,4 cm / 48 x 60 in., Acryl auf Leinwand / acrylic on canvas. **Nicht in der Ausstellung gezeigt** / Not included in the exhibition.

weise hellen Haut wegen, die ihre „multipel situierte ethnische Identität"[1] verbirgt, häufig nicht zur Kenntnis genommen. Folglich sind ihre Darstellungen keine Reproduktionen davon, wie der eigene Körper von anderen gesehen wird, sondern Umstülpungen von innen nach außen, Beschreibung dessen, wie es ist, in einem Körper zu leben, der immerzu die „Schablonen der Identität" in Frage stellt, „welche auf Lesbarkeit und Durchsichtigkeit beruhen".[2] Es fallen einem die Worte von Kevin Quashie ein, der das Innenleben als „den inneren Vorrat an Gedanken, Gefühlen, Sehnsüchten, Befürchtungen, Ambitionen" definierte, die „ein menschliches Selbst formen".[3] Genau diese innere Landschaft aus Widersprüchen breitet sich inmitten der verführerischen und doch fast bedrohlichen Gestalten von Quarles aus. Man bedenke nur, auf was für eine enorme Vielfalt an Stilen aus der Kunstgeschichte sie referiert. Von Willem de Koonings verwirrenden, fleischlichen Frauen bis zu Maria Lassnigs Gesten, behauptet sich das kühne Werk von Quarles inmitten der Körperdarstellungen der Westlichen Malerei. Obwohl ihre Gemälde solche Hinweise selbstbewusst geben, sind sie von den Traditionen, die mit ihnen verbunden sind, nicht belastet. Tatsächlich hat sie

how the body is viewed externally, but rather a reversal from the inside out, a depiction of what it is like to live within a body that continues to challenge the "matrices of identity that rely on readability and transparency."[2] What spring to mind are the words of Kevin Quashie, who defines the interior as "the inner reservoir of

1 Christina Quarles im Gespräch mit dem Autor.
2 Uri McMillan, „When the Clouds Clear, We'll Know the Colors of the Sky: Christina Quarles's Gestural Lines of Flight", in: Grace Deveney, Mark Godfrey, Uri McMillan (Hg.), Christina Quarles, München, London, New York: Del Monico Books, Prestel 2019, S. 26.
3 Kevin Quashie, The Sovereignty of Quiet: Beyond Resistance in Black Culture, New Brunswick, NJ: Rutgers University Press 2012, S. 21.

1 Christina Quarles in conversation with the author.
2 Uri McMillan, "When the Clouds Clear, We'll Know the Colors of the Sky: Christina Quarles's Gestural Lines of Flight," in: Grace Deveney, Mark Godfrey, and Uri McMillan (eds.), Christina Quarles, Munich, London, New York: Del Monico Books, Prestel, 2019, p. 26.
3 Kevin Quashie, The Sovereignty of Quiet: Beyond Resistance in Black Culture, New Brunswick, NJ: Rutgers University Press, 2012, p. 21.

„ein feines Gespür für die Erbschaften, die ihr zukommen und die sie verwandelt [...]. Und doch zitiert Quarles diese Vorläufer nicht, um historische oder zeitgenössische Mal-Diskurse zu kommentieren. Ganz Vertreterin ihrer Generation, hat sie weder das Gefühl, sie müsse die unerfüllten Versprechungen der Malerei bedauern, noch, deren Dringlichkeit im gegenwärtigen Augenblick verteidigen."[4]

Christina Quarles. Collapsed Time, die erste institutionelle Einzelausstellung der Künstlerin in Deutschland, ist eine Gelegenheit, sie in einen Dialog mit den Werken von einigen der ikonischsten Künstler*innen des Hamburger Bahnhofs, Nationalgalerie der Gegenwart, zu bringen. Die Absicht dahinter ist, die übliche kunsthistorische Einteilung in Generationen aufzugeben und auf diese Weise aufzuzeigen, in welch vielfältiger Weise Quarles' Werk formale und semantische Herangehensweisen vieler Künstler*innen der Sammlung spiegelt. Noch wichtiger vielleicht ist, dass der Begriff des Zusammenbruchs der Zeit unmittelbar auf die Grenzsituation sowohl der Figuren in den Gemälden von Quarles als auch der Themen verweist, die die ausgewählten Werke aus dem Hamburger Bahnhof behandeln. Wer sich die Szenen auf den Gemälden der Künstlerin genauer betrachtet, wird nur mit Mühe unterscheiden können, ob sich gerade eine Aktion

thoughts, feelings, desires, fears, ambitions that shape a human self."[3] It is precisely this internal landscape of contradictions that dwells within Quarles's seductive, yet almost intimidating figures. Consider the broad range of styles that Quarles references from the history of painting. Ranging from Willem de Kooning's disorienting, fleshy women to Maria Lassing's gestures, Quarles's bold work sits firmly within the genre of portraiture, and the nude in particular. Yet, while assertive in their indications, Quarles's paintings are not burdened by the lineage they build upon. As a matter of fact, "Quarles is keenly attuned to the legacies she inherits and transforms... Yet Quarles does not quote these precursors in order to comment on historical and contemporary painting discourses: as someone of her generation, she feels neither a need to mourn painting's unfulfilled promises nor defend its urgency for the present moment."[4]

Christina Quarles: Collapsed Time, the artist's first institutional solo presentation in Germany, is an opportunity to bring her oeuvre into conversation with works by some of the most iconic artists in the holdings of Hamburger Bahnhof, National Gallery of Contemporary Art. The intention in doing so is to collapse the generational divisions that operate within art historical lineages, revealing the multiple ways in which Quarles's work echoes some of the formal and semantic attributes of many of the artists within our collection. Perhaps more significantly, the notion of a collapse in time in this case makes direct reference to the liminal predicament of both the figures in Quarles's paintings and the subjects tackled by pieces selected from the Hamburger Bahnhof's collection. When one looks closely at the scenes that occupy the artist's paintings, one is racked trying to decipher whether one is witnessing an action that has just unfolded, or one that is about to unravel. Quarles's figures seem to be suspended in a dimension that lies outside of time: are we wit-

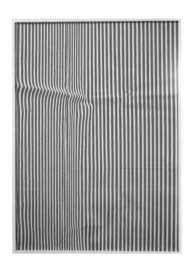

Annette Kelm, *Red Stripes 1,* 2018, Farbfotografie / colour photograph, 102,2 x 77,1 cm / 40 1/4 x 30 3/8 in., Staatliche Museen zu Berlin, Nationalgalerie, Dauerleihgabe der / permanent loan of the Peter und Irene Ludwig-Stiftung

4 Mark Godfrey, „Liquid Construction",
in: Deveney, Godfrey, McMillan (Hg.),
Christina Quarles, a.a.O., S. 83.

4 Mark Godfrey, "Liquid Constructions,"
in: Deveney, Godfrey, McMillan (eds.),
Christina Quarles, p. 83.

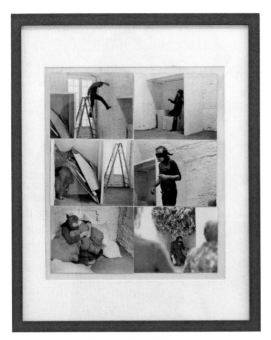

Vito Acconci, *ohne Titel / untitled,* 1972, Collage aus 6 s/w Fotografien einer Performance auf der / collage of 6 b/w photographs of a performance at **documenta 5** in Kassel, 1972, 33 x 28,5 cm / 13 x 11 1/4 in., Staatliche Museen zu Berlin, Nationalgalerie, 2002 erworben von / purchased from Egidio Marzona

nessing a vivid memory, a moment in occurrence, or perhaps the beginning of an unpredictable ending? Similarly, many of the works that we have jointly selected with Quarles seem to capture a situation of transition that eludes the strict logic of linear time. From pioneering conceptual Dutch artist Stanley Brouwn's 1969 painting *Hotel* to contemporary German artist Annette Kelm's photograph *Red Stripes 1* from 2018, elements of repetition and seriality, rupture and continuity, precision and chance, and a constant oscillation between finitude and infinity, both spatially and temporally, abound. All these diverse, seemingly contrasting elements speak to an unremitting desire to collapse the boundaries of time and space, allowing for new dimensions to emerge which are at once familiar and discernible as well as elusive and ambiguous. Those are the common grounds that Quarles's works share with these selections. They are dispersed throughout the gallery behind architectural constructions made of gauze fabrics that Quarles has conceived as an additional layer permeating the entire exhibition. The alternation of opacity and translucence, clarity and fuzziness, renders the notion of blurred space and time more present.

ereignet hat oder ob sie im Begriff ist, sich zu ereignen. Die Figuren von Quarles scheinen festgehalten in einer Dimension außerhalb der Zeit: Betrachten wir eine lebendige Erinnerung oder befinden wir uns vielmehr im Augenblick des Geschehens oder gar am Beginn eines unvorhersehbaren Endes? Entsprechend haben wir gemeinsam mit Quarles Werke ausgewählt, die eine Übergangssituation einfangen, welche sich der strikten Logik einer linearen Zeit entzieht. Von *Hotel,* dem 1969 entstandenen Gemälde des holländischen Konzeptkunstpioniers Stanley Brouwn, bis zu Annette Kelms Fotografie *Red Stripes 1* aus dem Jahr 2018, sind die Arbeiten reich an Wiederholung und Serialität, Bruch und Kontinuität, Präzision und Kontingenz sowie dem beständigen Oszillieren zwischen Endlichkeit und Unendlichkeit. Sie sprechen vom nicht nachlassenden Bedürfnis, die Grenzen von Zeit und Raum zu sprengen und neue Dimensionen hervortreten zu lassen, die vertraut und klar erkennbar, zugleich schwer fassbar und vieldeutig sind. Diese Gemeinsamkeiten

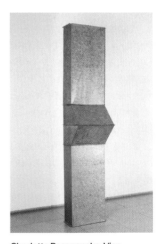

Charlotte Posenenske, *Vier verzinkte Elemente Serie D,* 1967, verzinktes Stahlblech, zweiteilig / galvanised steel plate, 2 pieces, 232 x 50 x 50 cm / 91 1/8 x 19 1/4 x 19 1/4 in., Staatliche Museen zu Berlin, Nationalgalerie, 2014 Schenkung durch / gift of Egidio Marzona

verbinden die Arbeiten von Quarles mit den ausgewählten Werken aus der Sammlung. Sie sind verstreut über die gesamte Ausstellungsfläche und befinden sich hinter Gazestoff, den Quarles als eine zusätzliche Schicht konzipiert, welche sich durch die gesamte Ausstellung zieht. Das Wechselspiel von Undurchsichtigkeit und Durchlässigkeit, Klarheit und Unschärfe führt die Vorstellung eines Verwischens von Zeit und Raum noch deutlicher vor Augen.

Hier einige Beispiele:

Im ersten Ausstellungsraum befinden sich mehrere der Gemälde von Quarles sowie ihre ortsspezifische Installation *Now We're There (And We' Only Just Begun)* in unmittelbarer Nähe zu einer Fotoserie, die Vito Acconcis Performance *Cross-Fronts* auf der documenta 5 (1972) dokumentiert. Acconci erkundet mit verbundenen Augen die Psychologie eines Territoriums und führt dabei eine Folge von Aktionen durch. Die Begegnung mit dem Raum, die auf andere Sinne als den des Sehens angewiesen ist, erweitern, auch dank Interventionen vonseiten des Publikums, das Verständnis des Künstlers von den Grenzen, die ihm als sich selbst genügender Einheit gesetzt sind, und erlauben neue Interaktionsformen zwischen dem Körper und dem Raum, in dem er existiert. Ganz ähnlich befinden sich auch die Körper von Quarles ständig auf der Suche nach einer neuen Vernetzung mit den Räumen, die sie bewohnen. Das Zusammenspiel der Ebenen stellt gleichzeitig Hemmnisse her und eine Verbindung in eine andere Dimension dar. Ebenfalls im ersten Raum befindet sich ein Werk von Charlotte Posenenske, das aus zwei identischen, übereinandergestapelten Elementen besteht und eine unerwartete visuelle Parallele zu den Verdichtungen von Körpern bietet, wie sie auf

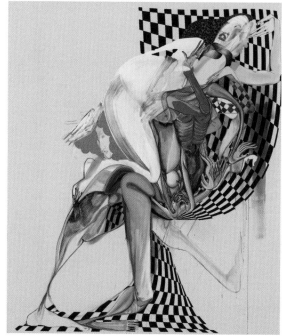

Christina Quarles, *Caught Up*, 2021, 213,4 x 182,9 cm / 84 x 72 in., Acryl auf Leinwand / acrylic on canvas. Nicht in der Ausstellung gezeigt / Not included in the exhibition.

Here are a few examples:

In the first gallery, several of Quarles's paintings, including her site-specific installation *Now We're There (And We' Only Just Begun)*, are in close proximity to a series of photographs documenting Vito Acconci's performance *Cross-Fronts* shown at documenta 5 in 1972. In an exploration of the psychology of territory, a blindfolded Acconci performs a sequence of actions. The encounter with the space, which relies on senses other than vision, along with interventions from a live audience, extend the artist's comprehension of his limitations as a self-sufficient entity, allowing for new forms of interaction to arise between his body and the space in which it exists. In a similar sense, Quarles's bodies seem to

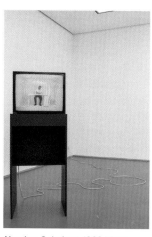

Absalon, *Solutions*, 1992, Video, Farbe, Ton / video, colour, sound, 7:50 min, Staatliche Museen zu Berlin, Nationalgalerie, 2008 Schenkung der / gift of the Friedrich Christian Flick Collection

vielen der Gemälde von Quarles zu sehen sind.

Im zweiten Raum entspinnt sich ein Dialog zwischen Quarles und Daniel Buren, genauer gesagt mit seinem Werk *Ein Tanz mit einem Quadrat* von 1989. Buren, der sich seit den 1960er-Jahren von der konventionellen Malerei wegbewegt hat, hat die Entwicklung einer visuellen Sprache vorangetrieben, die neuartige Formen ästhetischer Wahrnehmung bietet und von allem Narrativen und aller Bedeutung befreit ist. Die vertikalen Balken und sich abwechselnden Farbstreifen in *Ein Tanz mit einem Quadrat* lassen den spielerischen und doch überaus präzisen Einsatz geometrischer Formen erkennen, wie er sich auch auf vielen der Gemälde von Quarles findet.

Absalons etwa sieben Minuten langes Video *Solutions* aus dem Jahr 1992 im dritten Ausstellungsraum führt mitten in ein weißes, monochromes Interieur, in dem der Künstler unablässig die scheinbar unendlichen Möglichkeiten austestet, sich in einem derart engen Raum zu bewegen. Er will herausfinden, welche Funktionen sein Körper darin noch ausüben kann. Ist er eingesperrt oder hat er sich freiwillig in die Selbstisolation zurückgezogen? Werden wir Zeugen einer wiederholten Darbietung von Absalons schrecklichsten und intimsten Gedanken oder lädt uns der Künstler dazu ein, uns an seiner Kerkerhaft zu beteiligen? Auch auf den Gemälden von Quarles scheinen Figuren mit alldem zu kämpfen, was den von ihnen bewohnten Raum einengt.

Eines von Nam June Paiks frühesten Werken, *Zen for TV* aus dem Jahr 1963, blinzelt im vierten Saal aus einer der architektonischen Konstruktionen von Quarles hervor. Das Werk, zu dem Paik immer wieder zurückkehrte und das er seine ganze künstlerische Laufbahn hindurch verbesserte – auch dies eine Zeitausdehnung –, hat seinen Ursprung in einem Unfall, als bei einem Transport ein Fernsehapparat beschädigt wurde und dann nur noch in der Mitte des Bildschirms eine einzige kollabierte Zeile zeigte. Hochkant auf die Seite gestellt, wirkt die Linie sogar noch gepresster und noch mehr von den schwarzen Streifen auf beiden Seiten eingezwängt. Wie Paiks Bildschirmzeile beharrlich versucht, den Parame-

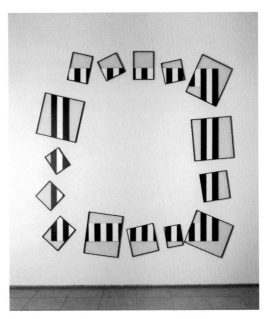

Daniel Buren, *Ein Tanz mit einem Quadrat*, 1989, Vinyl auf Glas, 15-teilig / vinyl on glass, 15 pieces, 255 x 255 cm / 100 1/8 x 100 1/8 in., Staatliche Museen zu Berlin, Nationalgalerie, 2014 Schenkung durch / gift of Egidio Marzona

be in a constant search for a new relationality to the spaces they inhabit. The interplay of planes acts at once as a barrier of restraint and a conduit to another dimension. Also in the first gallery, Charlotte Posenenske's work composed of two identical units stacked on top of each other provides an unexpected visual parallel with the compression of bodies that appears in many of Quarles's paintings.

In the second gallery, a dialog unfolds between Quarles and Daniel Buren, more specifically his *Ein Tanz mit einem Quadrat* [A dance with a square], 1989. Moving away from conventional painting since the 1960s, Buren has been advancing a visual language that provides novel forms of aesthetic perception, stripped from narrative or meaning. The employment of vertical bars and alternating color strips in *Ein Tanz mit einem Quadrat* reveals a playful, yet acutely precise employment of geometric forms that is a powerful presence in many of Quarles's paintings.

In the third gallery, Absalon's circa seven-minute video, *Solutions*, from 1992, centers on a white, monochromatic interior in which the artist persistently interrogates the ostensibly endless possibilities of how to navigate such a

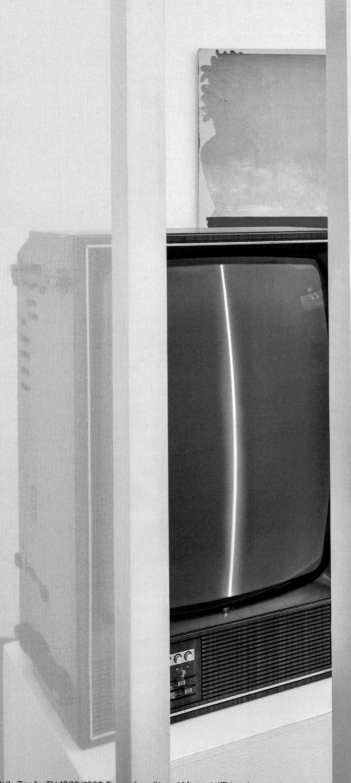

Nam June Paik, *Zen for TV*, 1963/1990, Fernsehgerät und Magnet / TV and magnet, 67,5 x 47,5 x 38,5 cm / 26 9/16 x 18 11/16 x 15 3/16 in., Staatliche Museen zu Berlin, Nationalgalerie, 1993 Schenkung durch / gift of Nam June Paik

Stanley Brouwn, *Hotel,* 1969, Kugelschreiber auf Holz
/ ballpoint pen on wood, 122 x 122 cm / 44 x 44 in.,
Staatliche Museen zu Berlin, Nationalgalerie, 2002
erworben von / purchased from Egidio Marzona

tern ihres Behältnisses zu entkommen, rebellieren die Körper von Quarles unerschütterlich und unermüdlich gegen von Traditionen aufgezwungene Rollen und gegen die Räume, in denen sie verharren. Paiks Praxis, seinen Werken spielerische Titel wie *Zen for TV* zu geben, findet sich in nahezu allen Titeln wieder, die Quarles für ihre Gemälde und Papierarbeiten gewählt hat.

Es ist selten, dass das Werk einer einzelnen Künstlerin so kraftvoll, so mühelos mit so vielen ihrer Vorläufer*innen und Zeitgenoss*innen in einen Dialog treten kann. Christina Quarles ist solch eine Künstlerin. Abgesehen davon, dass sie einem neuen Publikum hier in Berlin eine dringend notwendige Einführung in ihre fesselnde und einzigartige Malerei gibt, eröffnet uns ihre Ausstellung die Möglichkeit, neu über Werke unserer Sammlung nachzudenken, sie mit neuen Lesarten zu bereichern und die von ihnen beförderten ästhetischen Erfahrungen und den von ihnen angestoßenen intellektuellen Austausch zu erweitern. Am wichtigsten ist aber die verblüffende Fähigkeit von Quarles, die Welt als einen Ort zu entwerfen, an dem die Körper den Beschränkungen auf eine einzige Identität und den abgenutzten Markern, die auf Begriffe von Rasse, Geschlecht und Sexualität festklopfen sollen, trotzen. Das verleiht ihrer Ausstellung ihre Dringlichkeit und ihre Aktualität.

confined space and the functions his body can perform within it. Is he incarcerated or has he intentionally retreated into self-isolation? Are we witnessing a repeated display of Absalon's most terrifying inner thoughts, or is the artist inviting us to be complicit in his incarceration? In Quarles's paintings, too, figures often seem to struggle with components of interiors limiting the spaces they inhabit.

In the fourth gallery, one of Nam June Paik's earliest works, *Zen for TV*, from 1963, peeks through one of Quarles's architectural constructions. This work, to which Paik returned and continued to perfect throughout his career—another expansion of time—was born out of an accident when a TV set damaged during transit showed a singular, collapsed line across the center of its screen. With the TV flipped sideways, the now vertical line appears even more confined, restrained by the wide black bands that frame it on both sides. Similar to the insistence of Paik's, striving to escape the parameters of its container, Quarles's bodies are unyielding and relentless in their noncompliance with the roles that tradition has assigned them, and the spaces in which they exist. Paik's practice of playfully titling works, such as *Zen for TV*, is echoed in almost all the titles chosen by Quarles for her paintings and works on paper.

It is rather rare that a single artist's work can speak so strongly, so effortlessly to that of so many of their predecessors and peers. Christina Quarles is one such artist. Her exhibition at Hamburger Bahnhof, besides being a necessary introduction of her compellingly unique style of painting to a new audience here in Berlin, presents us with the opportunity to rethink works from our collection, imbuing them with new readings, and expanding the aesthetic experiences and intellectual exchange that they can facilitate. But most importantly, it is Quarles's uncanny ability to conceive of the world as a place where bodies defy the limitations of singular identities and worn-out markers of fixed notions of race, gender, and sexuality that makes her exhibition here urgent and timely.

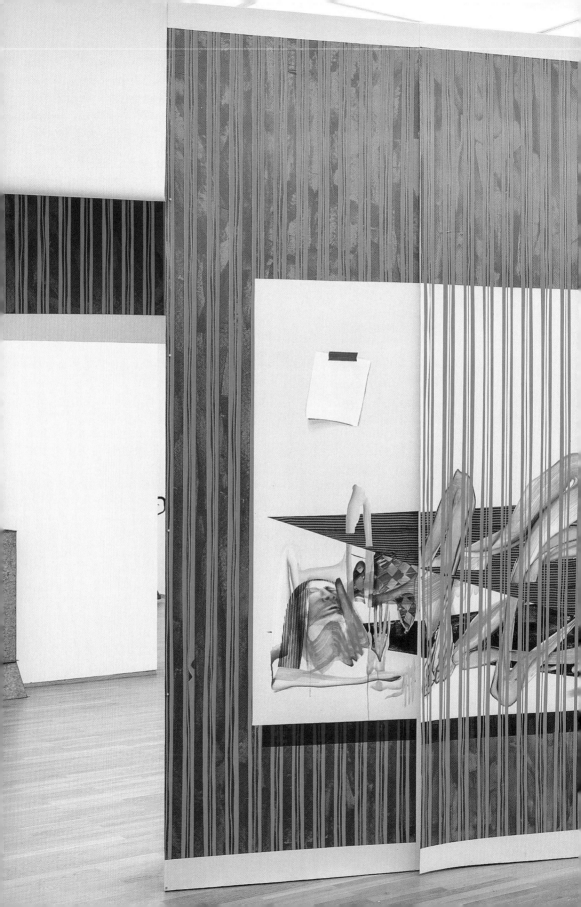

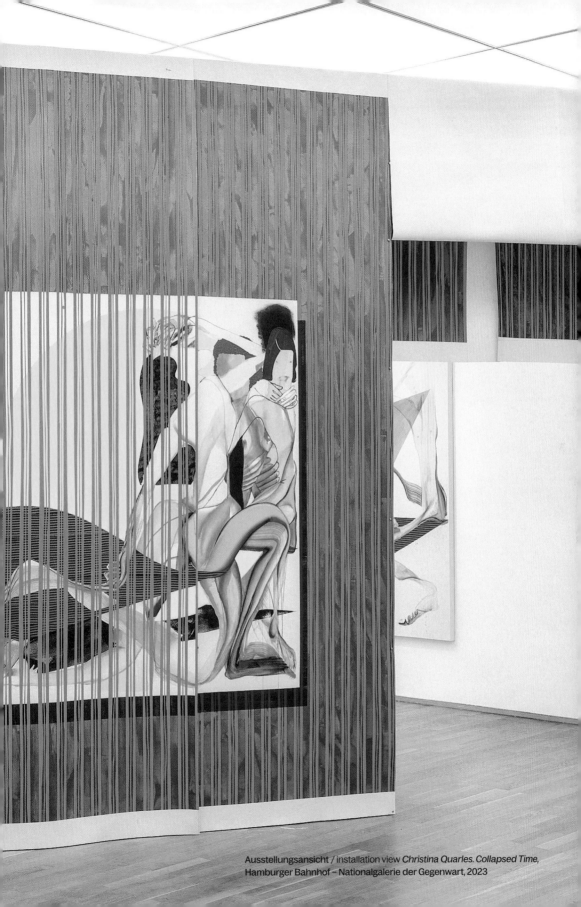

Ausstellungsansicht / installation view *Christina Quarles. Collapsed Time,*
Hamburger Bahnhof – Nationalgalerie der Gegenwart, 2023

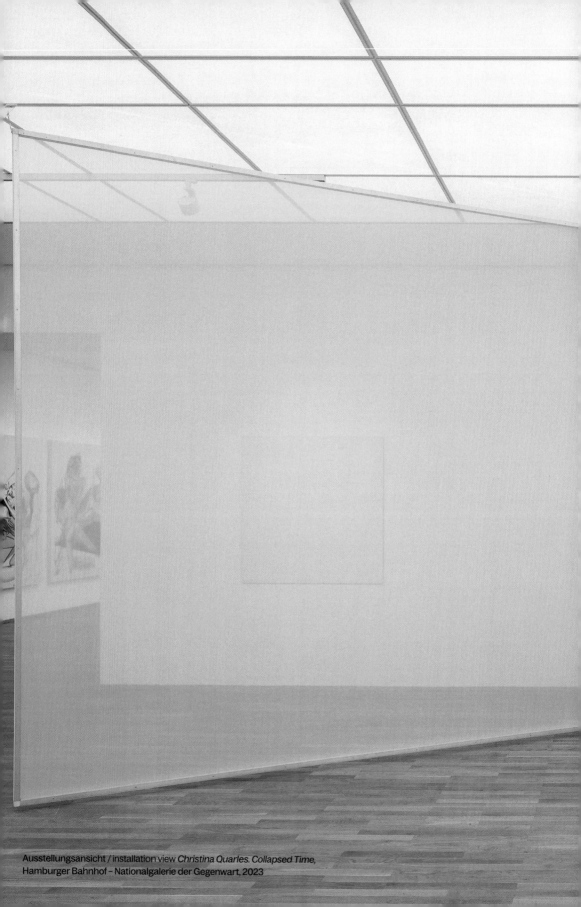

Ausstellungsansicht / installation view *Christina Quarles. Collapsed Time*,
Hamburger Bahnhof – Nationalgalerie der Gegenwart, 2023

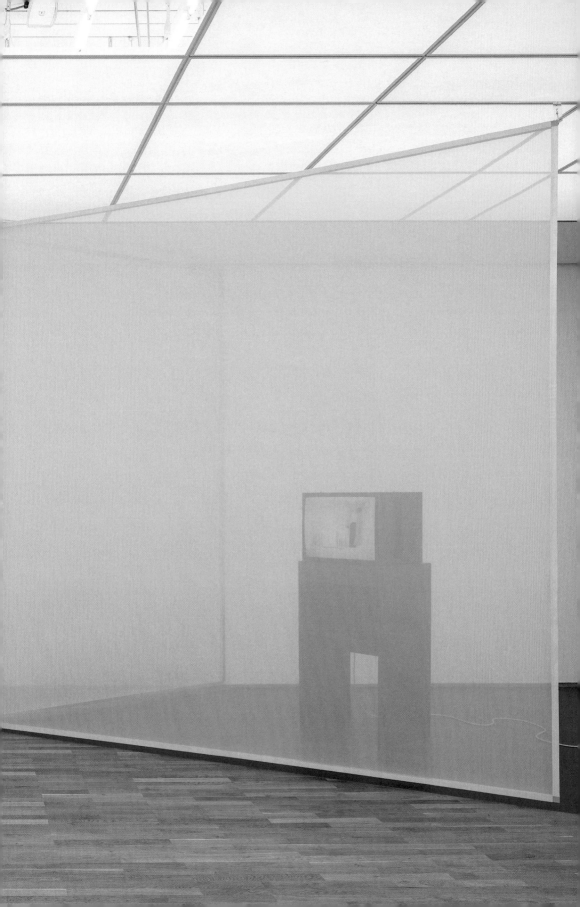

Ausstellungsansicht / installation view *Christina Quarles. Collapsed Time*,
Hamburger Bahnhof – Nationalgalerie der Gegenwart, 2023

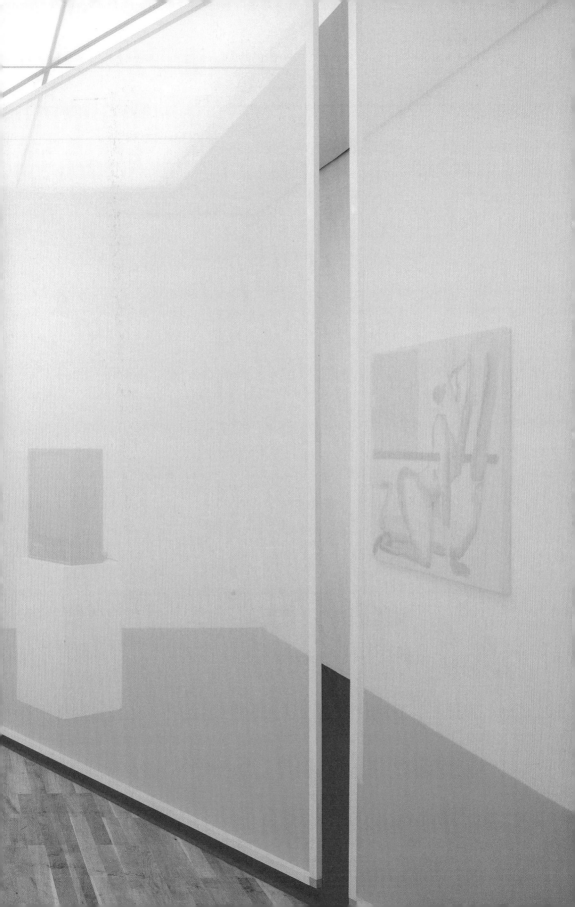

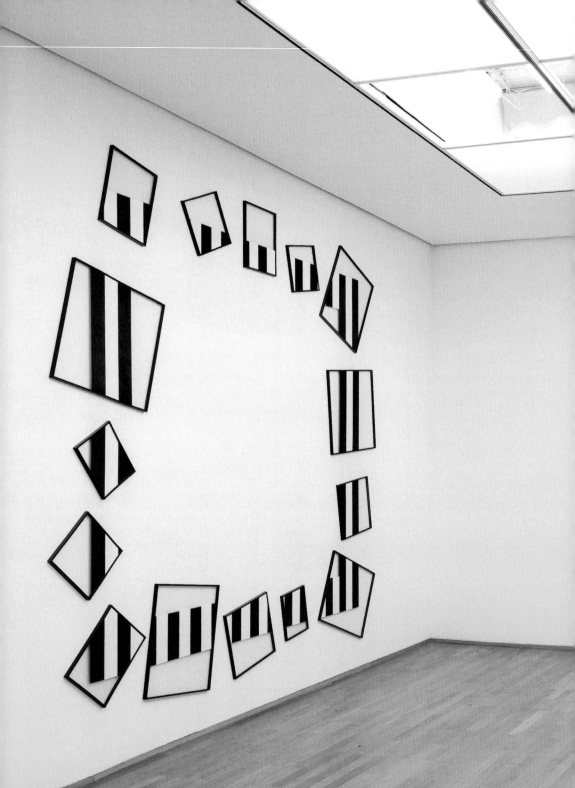

Ausstellungsansicht / installation view *Christina Quarles. Collapsed Time,*
Hamburger Bahnhof – Nationalgalerie der Gegenwart, 2023

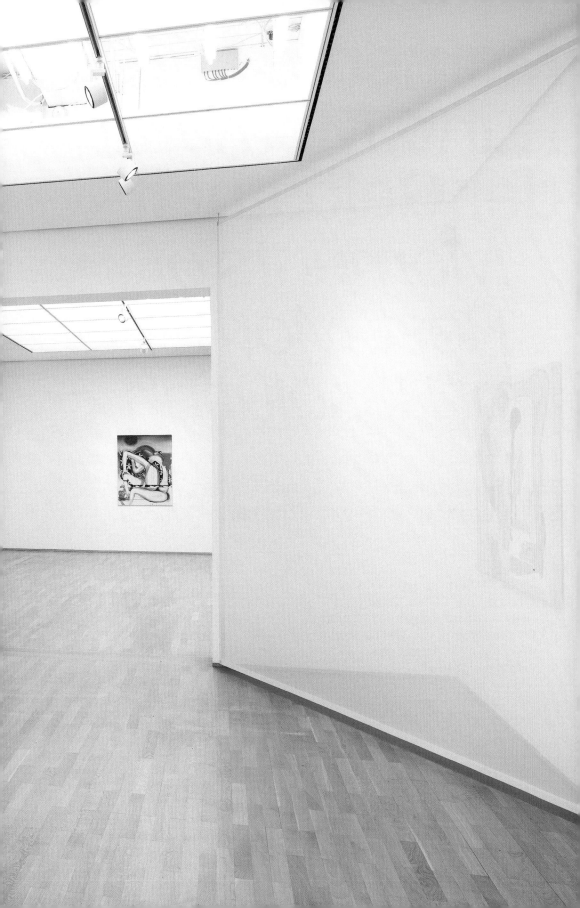

Momente der Ruhe, Momente der Gelöstheit / *Moments of Rest, Moments of Resolution*

Eine Unterhaltung / A Conversation: Sam Bardaouil mit / with Christina Quarles

Sam Bardaouil Christina, wir kennen uns nun schon ein paar Jahre. Deine Gemälde lösen bei einer Person, die sie betrachtet, eine Menge starker Gefühle aus, und das erste, an das ich mich entsinne, ist ein Empfinden gleichzeitig von Anziehung und Furcht. Es war mir nicht klar, ob ich nun vor einer heiteren und verspielten Szene stehe oder vor einer, die etwas viel Dunkleres verbirgt. Und dieser Widerspruch, diese beiden Pole von Anziehung und Bedrohung scheinen mir in vielen deiner Werke wiederzukehren. Wo kommt das her?

Christina Quarles Wenn ich beobachte, wie Leute auf mein Werk reagieren, schätze ich es wirklich sehr, wenn jemand diese beiden Seiten

Sam Bardaouil Christina, we've known each other for a few years now. I think your paintings do bring out a lot of strong emotion in the person that experiences them and the first thing that I remember feeling is a sense of attraction and fear. I couldn't figure out whether I was looking at an environment that was joyful and playful or one that was camouflaging something that is actually much darker. And in a sense this contradiction, these two poles of attraction and menace seem to me like something that appears in a lot of your work. Where is that coming from?

Christina Quarles Something I find interesting, as somebody who makes the work but then also as somebody who gets to observe people

sehen kann und nicht bloß eine. Ich glaube, wir sind dazu erzogen, Widersprüche auszublenden und stets das eine dem andern vorzuziehen. Wenn du deine Erfahrung nicht zur allereinfachsten oder am leichtesten erklärbaren versimpelst und wenn du ehrlich mit dir bleibst, hast du immer diese Gegensatzpaare – und alles, was zwischen ihnen liegt.

Ich gehe die Gemälde mit diesem körperlichen Drang an, die Figur zu gestalten. Mein Körper und die Widerstände der Leinwand wirken also zusammen. Wenn ich an die Leinwand trete, habe ich keine Vorzeichnungen parat, es ist wirklich diese Art von körperlichem Zusammenspiel zwischen der Ausdehnung der Figur innerhalb der Leinwand und dem Bewusstsein von deren Rändern. Was die Komposition betrifft, wird eine Spannung erzeugt zwischen einerseits diesem künstlerischen Handeln und der Aktivität innerhalb des Rahmens und andererseits dieser Beschränkung und Einengung. Das stellt sich mir ganz körperlich und stofflich dar.

Aber mir ist auch klar geworden, dass darin eine hilfreiche Parallele zu manchen der Motive und Ideen liegt, die meine Arbeit antreiben. Am Gedanken der Lesbarkeit bin ich wirklich interessiert, etwa daran, dass wir uns zum Lesbaren hingezogen fühlen und es bei uns selbst suchen, weil wir von unserer Gemeinschaft, von anderen Menschen gesehen und verstanden werden wollen. Doch verlaufen die Grenzen der Lesbarkeit genau da, wo jemand sich auf eine Lesart meines Werks versteifen will, anstatt es komplexer, widersprüchlicher zu sehen. So glaube ich, dass dadurch, dass die Lesbarkeit einerseits eingeschränkt ist und wir uns andererseits nach ihr sehnen, genau die Spannung aufgebaut wird, die uns zu den feinsten Sensoren unserer Erfahrungen und unserer Selbstwahrnehmung macht. Diese Spannung entsteht dadurch, dass wir, um uns sowohl von uns selbst als auch von anderen Menschen verstanden zu fühlen, unsere Erfahrung zurechtstutzen.

sʙ Du sprichst von Lesbarkeit, davon, wiedererkannt, verständlich zu sein und dich mit andern zu verbinden, und verdeckst

interacting with the work, is that I always really appreciate it when people can see both of those things instead of one or the other. I think we're somehow trained to ignore contradiction and will usually choose one over the other. But I find that, if you're being honest about what an experience is rather than trying to have it be the most simplified or explainable experience, it actually usually is a little bit of these polar opposites—and then everything that's in between.

I come at the paintings with this physical impulse of rendering the figure. And so, for me, it's really an interplay between my own physical body and the restraints of the canvas.

When I approach the canvas, it's not from sketches, it's really just about that sort of physical interplay between the expanse of the figure within the canvas while being cognizant of the edge of the canvas. And so I think that that compositionally leads to that tension between there being this agency and this activation within the frame at the same time as this restraint and confinement. It's something that, for me, manifests in this very physical and material way.

But I've also found it to be this very helpful parallel to a lot of the content and ideas that propel my practice. I'm really interested in the terms of legibility and how, on the one hand, we're really drawn to the legible and seek it in ourselves, we want to be seen and understood by our community, by other people. But the limits of legibility are exactly what would make somebody have only one reading of my work instead of this more complex, contradictory reading of it. And so I think that it's that tension between the limit of legibility, but also the desire for it, that leads us to be our own greatest censors of our experience and our way of understanding ourselves. It's that sort of truncating of our experience in order to feel like we are understood both by ourselves and by other people that leads to a sort of tension.

doch einige deiner Erfahrungen. Es geht mehr um die Verbindung zwischen Menschen als um deren figürliche Abbildung. Wir lesen oft über Künstler*innen, die mit dem menschlichen Körper als Motiv arbeiten und da wird viel über den Begriff der Abbildung diskutiert. Bei deinem Werk habe ich aber den Eindruck, es handele weniger von Abbildung und mehr von Verbindung, da die Körper nur selten isoliert erscheinen, und selbst dann gibt es immer eine Spur eines anderen Wesens, das da war oder im Begriff ist, auf der Bildfläche zu erscheinen. Was bedeutet dir – ganz allgemein gesprochen, nicht nur in Beziehung auf Malerei – Verbindung zwischen Menschen? Wann hast du den Eindruck, du nimmst Kontakt mit einer andern Person auf?

CQ Interessant, das Wort habe ich selbst noch nie gebraucht: Verbindung. Aber es bietet glaube ich eine wunderbare Möglichkeit, diese Gemälde und Kompositionen zu erkunden und anhand des Körpers den Gegensatz von Verbindung und Abbildung zu erörtern. Ich habe das auf andere Weise beschrieben, aber es kommt wohl auf dasselbe heraus: Mich interessiert nicht die Erfahrung, einen Körper zu betrachten, sondern die, im eigenen Körper zu leben. Und das ist eine des Suchens nach Verbindung, und es ist ein Suchen nach Verbindung mithilfe anderer, um so auch sich selbst besser zu begreifen.

Die multiplen Figuren innerhalb der Kompositionen meines Werks sehe ich manchmal als getrennt, aber vielfältig, manchmal als eine vollständige Figur, die sich durch Zeit und Raum der Komposition bewegt oder auf Schatten und Reflexion reagiert. Die Vorstellung von einer Verbindung wird noch komplizierter, bedenkt man, wie sich die Verbindung zum eigenen Selbstgefühl herstellt. Wer sich kennen will, gerät in eine Zwickmühle. Einerseits: Wer könnte dich besser kennen als du dich selbst? Andererseits sind wir auf diese wirklich isolierte Erfahrung zurückgeworfen, in unserem Selbst, in unseren Körpern zu sein, weil wir alle andern als visuell ganze Wesen wahrnehmen,

SB You talk about legibility, on one hand wanting to be recognized, to be readable, to connect, while at the same time obscuring some of your experiences. It's more about human connection rather than human representation. I think we often read about artists who work with the human body or the figure as the main motif, and a lot of the discussion goes into the notion of representation. I feel that your work is less about representation and more about connection, because the bodies very rarely appear in an isolated situation and, even if they do, there's always a trace of another being that was there or is about to enter into the picture plane. Generally, not just in painting, what does human connection mean to you? When do you think you connect with another person?

CQ It's interesting, I have not actually used that word before: connection. But I think it's a wonderful way of exploring these paintings and compositions, using the body to be a way of discussing connection vs. representation. I've used other ways of describing it, which I think get to the same conclusion, which is that I'm interested in the experience of living within your own body instead of the experience of looking at a body. And I think that experience is one of seeking connection, and it's seeking connection through other people to also gain a better understanding of oneself.

In the work, I will see the multiple figures within the compositions as sometimes being discrete, multiple figures, but other times as being a single figure that's moving through the time and space of the composition or interacting with shadow or reflection. That idea of connection becomes even more complicated when you think about how you connect with your own sense of self. We're really at the disadvantage of knowing ourselves. On the one hand, who could know yourself better than yourself? On the other, we have this very isolating experience, being within our own selves, our own bodies, because we experience everyone else as visually unified beings, whereas we

während wir uns selbst als dieses Bündel von Teilen oder aber als Reflexion in einem Spiegel, viel flacher, viel frontaler, wahrnehmen. Wann immer ich an mir selbst herunterschaue, sehe ich diese Glieder und Hände und Füße in seltsamer Unverbundenheit mit meinem Gesicht. Andere sehen wir als Ganze. Für mich bist du eine in sich ziemlich geschlossene Person. Ich aber bin verstreut! Es gibt also diese falsche Erwartung, wir würden uns sehr genau kennen oder wären unserem Selbstgefühl innig verbunden. Denn in Wahrheit suchen wir stets nach dieser Einfachheit, die uns der Anblick der andern vorgaukelt.

In meinem Werk gibt es immer diesen Moment der Verbundenheit oder der Zärtlichkeit oder des Sichtbarwerdens.

Ich versuche, Mittel und Wege zu finden, diese Momente der Ruhe oder der Gelöstheit einzubringen, damit sich nicht immerzu alles verschiebt, nicht immer alles wegrutscht und unterlaufen oder in Frage gestellt wird. Ich habe diese Augenblicke als solche der Intimität mit einem selbst oder mit einer anderen Person oder mit anderen Personen beschrieben, vorübergehende Zusammenschließungen, bei denen sich all die chaotischen Dinge ordnen. Dabei meint Intimität nicht bloß Liebe oder Sexualität, sondern auch etwas, das sowohl lustvoll als auch schmerzhaft und beschwerlich sein kann, es gibt auch eine Intimität von Krankheit oder Trauer. Es gibt aber auch Momente, in denen diese Einfachheit, diese schlichte, entschlackte Seite der Dinge zwar gestört wird und sich verkompliziert, aber noch immer ein Kontakt besteht. Also diese Augenblicke, in denen, obwohl es widersprüchlich ist, noch Verbindung da ist, die beglückend, aber auch unerträglich sein kann und die sich, glaube ich, ohnehin nur für eine Weile hält. Es ist schwer durchzuhalten.

SB Das bringt mich zu einer Frage, die du wahrscheinlich ständig hörst: Wann war dir zum ersten Mal klar, dass du eine

see ourselves as this compilation of parts or reflection in a mirror that is much flatter, much more frontal. Whenever I look down at myself, I'm seeing limbs and hands and feet with this weird disconnection between my own face. With other people, we see them as this whole. So, to me, you seem like a very consistent person. Whereas I'm all over the place! There's this false expectation that we would know ourselves very intimately or have a deep connection with our sense of self. But actually, we're constantly searching for that false sense of simplicity that we see in other people.

And in my works, there always is this moment of connection or of tenderness or of really having things come into focus. I try to find ways in the painting of having those moments of rest, or moments of resolution, that then are constantly shifting and moving and being undermined or called into question. I've always described them as being moments of either intimacy with oneself, or with another person, or a set of people, momentary connections where things do align in their messiness. Thinking through the idea of intimacy as not being bound just to love or sex, but intimacy as being something that can be both pleasurable or painful and difficult, there can also be intimacy in sickness or mourning. But it's these moments where that simplicity, that simple, pared down face of things, gets broken down and complicated, and yet there's still connection. So, these moments where there's connection despite contradiction. Sometimes they can be joyful and sometimes they can be quite unbearable, but I think they're always momentary. It's quite difficult to sustain.

SB This brings me to a question that I'm sure you get all the time: when did you first realize that you're an artist? But I'm actually more interested in knowing: when did you first become very conscious and interested in the body, in the human body as a tool, as a subject, as a source? What are your earliest recollections of looking at your own body or other bodies and thinking, there's something that really intrigues me.

Künstlerin bist? Aber noch mehr interessiert mich, wann dir der Körper zum ersten Mal bewusst geworden ist und du dich für ihn interessiert hast, der menschliche Körper als ein Mittel, als ein Thema, als eine Quelle? Wann hast du zum ersten Mal deinen Körper, die Körper von anderen betrachtet und gedacht, da ist etwas, das mich wirklich sehr, sehr fasziniert?

cq Es scheint mir, als wäre das beides zur selben Zeit gekommen. Ich kann mich gar nicht an eine Zeit erinnern, in der ich nicht auf den Rändern meines Highschool-Schulhefts herumgekritzelt hätte und in der mir nicht bewusst gewesen wäre, einen Körper zu haben. Beides gehörte notwendig zu meiner Entwicklung. Aber ich war noch sehr jung, um die 12 Jahre alt, als ich damit anfing, über diese beiden Dinge ernsthafter und konzentrierter nachzudenken. Ich war in einer Zeichenklasse, die ich nahm, um eine Mappe zusammenzustellen. Los Angeles, wo ich aufgewachsen bin, hat furchtbare Highschools, das gilt sowohl die Privatschulen, die in diese Hollywood-Version von Geld und Ruhm verpackt sind, als auch für die unterfinanzierten und heruntergewirtschafteten öffentlichen Schulen. Als ich zur Middle School ging, gefiel mir weder die eine noch die andere Option. Ich stieß zufällig in einem Lebensmittelladen auf ein Teenie-Magazin, das in jeder Ausgabe eine andere Highschool der USA vorstellte. Zufällig kam in dieser Nummer eine High School in Los Angeles vor, voll mit Leuten, die cool und queer aussahen. Das war diese Highschool mit Schwerpunkt Kunst. Von da an wollte ich ernsthaft Künstlerin werden.

In einem Gemeindezentrum in L.A. nahm ich an einer Zeichenklasse teil, es gab welche für Kinder und Erwachsene, aber mich steckten sie versehentlich in die Erwachsenenklasse und da gab es auch ein Aktmodell. Sie erlaubten, dass ich in der Klasse bleibe, und ich hatte wirklich große Freude am Figurenzeichnen. Später bekam ich in der Highschool einen Lehrer, der enormen Einfluss auf meine heutige Praxis genommen hat, denn er lehrte Figurenzeichnung. Vieles von dem, was er uns darüber beigebracht hat, wie man einen

cq I feel like the two things did sort of happen at the same time. I can't think back to a time when I wasn't doodling in the margins of my high school notebook or a time when I wasn't aware that I had a body. Both were very integral to my entire development. But when I started thinking about those two things in a more serious and focused way, I was still very young, around 12 years old. It was in a figure drawing class that I was taking to build my portfolio. Los Angeles, which is where I grew up, has terrible high schools, the Hollywood version of money and fame wrapped up in private schools or these really underfunded and rundown public schools. I was in middle school and didn't really want to go to either of those two options. I was reading this teen girl magazine that focused on a different US high school in every issue. This one I was looking at in the grocery store just so happened to have this high school that was in Los Angeles and full of cool, queer looking people. And it was this arts high school. That's when I started getting really serious about becoming an artist.

I took a figure drawing class at this community center in L.A. where they had classes for adults and children and I was accidentally put into the adult class, which had a nude model. They let me stay in the class and I really loved drawing the figure. And then, in my high school, I also had a teacher who was very influential to my practice now, who was a figure drawing teacher. A lot of the ways that he taught us how to draw the body are things that have led to the stylistic approach to my pieces today.

sb When did you realize in life, not in art, that actually not all bodies are the same and that there are certain projections and associations that come with different types of bodies, whether we're talking about race, gender, different body shapes... When did you start realizing that not all bodies are treated equal because of the way they look?

cq The earliest times for me to know that bodies are seen and felt differently happened when I was very young, a kid on a playground at school.

Körper zeichnet, ist in den Stil meiner heutigen Arbeiten eingeflossen.

SB Wann ist dir – im Leben, nicht in der Kunst – aufgegangen, dass nicht alle Körper gleich sind und dass es da bestimmte Projektionen und Assoziationen auf und mit verschiedenen Körpertypen gibt, egal, ob es nun um Ethnie, Geschlecht, verschiedene Körperformen geht... Wann wurde dir klar, dass aufgrund ihres Aussehens nicht alle Körper gleichbehandelt werden?

CQ Das war auf dem Schulhof, als ich noch ein kleines Kind war. Da bemerkte ich zum ersten Mal, dass Körper unterschiedlich gesehen und empfunden werden. Wenn du in einer großen, internationalen Stadt wie Berlin oder Los Angeles bist, wo Leute von überallher zusammenkommen, dann fragen die Kinder auf dem Schulhof einander: „Wo kommst du denn her? Wie ist deine Familie so?" Und immer wenn ich sagte, dass mein Papa Schwarz und meine Mama *weiß* ist, riefen die Kinder: „Das stimmt nicht, du lügst, du bist nicht Schwarz." Oder sie fragten mich, warum ich Sommersprossen habe. „Mein Papa hat auch welche." – „Aha. Aber, halt, dein Papa ist Schwarz. Schwarze Leute haben keine Sommersprossen." Schon als kleines Kind, lange bevor ich das hätte ausdrücken können oder tiefergehende akademische Theorien darüber gelesen hätte, empfand ich den Schmerz und die Verwirrung, dass wenn ich auf die Frage, wer ich bin, die einzig wahre Antwort gab, auf Widerspruch traf und mir vorgeworfen wurde, ich lüge. Es wurde mir klar, dass jemandes inneres Selbstverständnis im Gegensatz dazu stehen könnte, wie man von anderen gelesen oder interpretiert wird. Das kann einem eine gewisse Freiheit verleihen, zu erkennen, dass es dieses Abgekoppeltsein gibt, denn plötzlich scheint es möglich, dass überhaupt alles, womit man sich identifiziert, abgekoppelt sein könnte und dass darin ein Potenzial liegt, die Erwartung außer Kraft zu setzen, wer du bist oder was eine bestimmte Identität genau auszumachen hätte. Die Begriffe, die mir zur Verfügung

When you are in a big international city like Berlin or Los Angeles and people are from all over the place, there are these questions that kids on the playground would just ask, like "Where are you from? What's your family like?" And whenever I would answer that my dad was Black and my mom was White, kids always responded in the same way: "That's not true, you're lying, you're not Black." Or they'd ask me why I had freckles. "My dad has freckles." – "Right. But wait, your dad is Black, Black people don't have freckles." And so even before I was able to articulate that or read deep academic theory about it, even just being a little kid, I felt the pain and confusion of having the only way to truthfully answer who I was be met with resistance, being accused of lying. And so it sort of opened up this possibility for me that one's internal self-understanding could be contradictory to how you're read or interpreted by other people. It can lead to a sense of freedom in a way, when you realize that there is that disconnect because suddenly it opens up the possibility that there could be a disconnect between all ways that you identify and that there could be a potential for there being more ways of exceeding that expectation of who you are or what a certain identity would encapsulate. The terms I could use to describe my experience always felt very lacking, especially with race. And so I really wanted to explore that.

SB When did you realize that art history and the history of painting perhaps evidence this resistance because bodies here, too, have had to comply with certain rules? If you had a certain race or gender, for instance, you appeared in a certain way. When did you start seeing that this is evident in historical or modern ways of depicting the body in art?

CQ Because I look white, usually, and especially to white people, and because so much of being biracial or being Black in America is about being in a body that's seen as non-white, especially by white people, that has led me to this interest in how to represent an experience that's not definable just by how you look. It goes back

standen, um meine Erfahrung auszudrücken, fühlten sich unzutreffend an, vor allem, wenn es um ethnische Fragen ging. Deshalb wollte ich wirklich mehr darüber herausfinden.

SB Wann hast du herausgefunden, dass sich in der Kunstgeschichte und in der Geschichte der Malerei Belege für diesen Widerstand finden, weil dort Körper gewissen Regeln unterliegen? Wer einer bestimmten Ethnie oder einem bestimmten Geschlecht angehört, sollte beispielsweise auf eine bestimmte Weise erscheinen. Wann hast du erkannt, dass das in der historischen oder modernen Körperdarstellung der Fall ist?

CQ Weil ich, wenigstens für *weiße* Leute, gewöhnlich *weiß* aussehe und weil in Amerika, *mixed-race* oder Schwarz zu sein, vor allem für *weiße* Leute gleichbedeutend damit ist, einen nicht-*weißen* Körper zu haben, habe ich mich damit beschäftigt, wie man eine Erfahrung einfangen könnte, die allein vom Sehen her nicht zu fixieren ist. Das ist wieder der Gedanke, dass man mehr über Verbindung als über Abbildung sprechen sollte. Darstellungen von Figur und Körper streben immer nach Abbildung. Das gilt sogar für manche Fälle in der zeitgenössischen Kunst, in der wir auf Schöpfer*innen stoßen, die ihre eigene Körper- und Erfahrungsgeschichten erzählen, welche im älteren Westlichen Kunstkanon sonst nicht vorkommen. Die Abbildung würde aber meine Erfahrung nicht abdecken, denn würde ich ein realistisches Porträt von mir anfertigen, würde es nicht beschreiben, was es bedeutet, in meinem Körper zu sein. Ich wollte eine visuelle Sprache und Bildsprache dafür finden, eine Erfahrung festzuhalten, die über das oberflächliche visuelle Abtasten eines Körpers hinausgeht.

Ich habe viel darüber herausgefunden, dass wir darauf konditioniert sind, bestimmte Informationseinheiten zu verarbeiten und andere, die ebenso auftauchen, auszublenden. Ich finde es spannend, wie Leute die Figuren auf meinen Gemälden beschreiben. Die Figuren werden für weiblich gehalten, was ich interessant finde, denn obwohl es sicherlich

to that idea of talking about connection rather than about representation. So many depictions of the figure and the body, even when you look at instances in more contemporary art where we are suddenly seeing people that are the authors of their own story talking about bodies and experiences that are not as familiar in the longer Western canon of art history, it's still this drive to find representation. And, for me, that idea of representation would fall short of my experience because, if I were to just show you a realist painting of myself, that wouldn't really describe my experience of being in my body. For me, it's really been this quest to find a way of using visual language and imagery to describe an experience that goes beyond the surface read of looking at a body.

I've learned a lot about how we are conditioned to read certain bits of information and have that override other bits of information that are being presented.

It's always interesting to me to observe how other people describe the figures in my paintings. They are always gendered as women, which I find really interesting because it certainly is not true, but there's many aspects of the figure that are more androgynous or could be either gender.

And there's so many things in the figures, in the paintings and the compositions that are not bound to realism. So it always is interesting to me when people find the need to pinpoint gender. There's nothing about the figures that anchors them to our entire reality because they do have four heads and they're purple and orange and all these different things. But people really try to lock it and decide that it's two women making love.

One of the things I've been thinking about more lately is that, when associating gender, there is also this assumption of a certain age of

nicht ganz falsch ist, gibt es doch auch viel Androgynes an ihnen, manche könnten beiden Geschlechtern angehören. An den Figuren, in den Gemälden und in den Kompositionen gibt es so vieles, das nicht dem Realismus verpflichtet ist. Es fällt deshalb immer auf, wenn Leute es für nötig halten, das Geschlecht zu bestimmen. Nichts an den Figuren positioniert sie irgendwo in unserer Wirklichkeit, immerhin haben sie vier Köpfe, sind lila und orange und derlei Abweichungen mehr. Aber die Leute versuchen, die Sache abschließend zu entscheiden, und dann sollen das eben zwei Frauen sein, die Liebe machen.

Zu den Dingen, über die ich in letzter Zeit verstärkt nachgedacht habe, gehört, dass wenn ein Geschlecht assoziiert wird, auch ein bestimmtes Lebensalter der Figur und ein bestimmter Körpertyp unterstellt wird. Wenn man aber veranschlagt, wie sich die Faktoren Alter und Dicksein oder Dünnsein gegenseitig beeinflussen, kann das die Geschlechtszuordnung von Körperteilen auf einem statischen Gemälde erheblich erschweren. Es gibt immer Brüste auf meinen Gemälden, mal flach, mal ziemlich üppig. Die Leute nehmen gewöhnlich an, dass die Figur auf dem Gemälde in Topform und 27 Jahre alt ist. Aber sobald du Jugend oder Alter, Übergewicht oder Untergewicht oder auch verschiedene Gesundheitsprobleme ins Spiel bringst, kann all das einen Einfluss darauf nehmen, warum man eine mehr oder weniger fleischige Brust hat.

SB Darin sehe ich eine weitere Methode, mit der deine Gemälde unterschiedliche Vorurteile bloßstellen. Denn wir verbinden Sexualität, Schönheit, Macht, alle Arten von Handlungsfähigkeit mit einem bestimmten Personentypus, einem bestimmten Alter, einem bestimmten Aussehen. Sobald jemand sich nicht mehr in dieses Schema einordnet, verschließen sich auch schon Handlungs- und Erfahrungsmöglichkeiten. Wie bewusst sind dir diese Fragen? In welchem Maße erscheint es dir ein politischer Akt zu sein, diese Figuren zu malen?

the figure and of a certain body type, and that as soon as you consider these intersections of age and of fatness or thinness, that that can really complicate the way that body parts are gendered in a static painting. There's always boobs in my paintings, whether the subjects are flat chested or really voluptuous. People usually assume that this figure in the painting is in their peak fitness and they're 27 years old. But as soon as you add adolescence or old age or being overweight or underweight or having different health issues, all these things can factor in why you would have a fleshier chest or not.

SB I feel this is another way through which your paintings are exposing different forms of prejudice. Because in a way, we associate sexuality, beauty, power, any type of agency with a certain kind of person, a certain age, a certain look. And the moment someone doesn't subscribe to these they are not usually allowed access to that same agency or to those experiences. How conscious are you of these questions? And in a sense, to what extent do you feel that you are committing a political act when you are painting these figures?

CQ One of the wonderful things about painting and drawing is that it's this static image in a way. It's not kinetic, it doesn't move. But it is an image that can still have this temporal quality and this way of unfolding, even if you see everything at once. And so I do try to play with this. That's why the figure and pattern are really helpful for me, because they're both these things that you can find recognition in almost immediately. I think that we try to find the figure and faces in everything that we look at because it's just human nature. We want to find the human in things. And so by adding a figure and then adding pattern and color, there are these ways of anchoring a familiarity within an initial static read. And then my hope is that there's things that can interest the viewer long enough to have that initial read broken down and turned into a second or third read, or start to have information that contradicts that first read. That's my goal with the work, to find a sense of politics

CQ Zu den wunderbaren Dingen an Malerei und Zeichnung gehört, dass sie ein gewissermaßen stillstehendes Bild erzeugen. Es ist nicht kinetisch, es bewegt sich nicht. Und doch kann das Bild eine zeitliche Qualität besitzen, eine Art von Entfaltung, selbst wenn du alles auf einmal anschaust. Damit versuche ich zu spielen. Deshalb helfen mir Figur und Muster sehr, denn man erkennt sie beide sofort wieder. Es ist einfach menschlich, dass wir in allem, was wir betrachten, Figur und Gesicht erkennen wollen. Wir wollen in den Dingen das Menschliche wiederfinden. Indem ich also Figur und danach Muster und Farbe hinzufüge, verankere ich das auf den ersten Blick statisch Wirkende in etwas Vertrautem. Meine Hoffnung ist, dass es Dinge gibt, die die Betrachter*innen lang genug interessieren, bis der erste Eindruck Risse erhält und in einen zweiten oder dritten Blick übergeht oder bis Informationen auftauchen, die dem ersten Eindruck zuwiderlaufen. Meine Absicht ist, innerhalb dieser Entfaltung und Verkomplizierung der visuellen Erfahrung auch einen politischen Sinn zu entdecken. Innerhalb des Werks verleiht er der Interpretation der Figuren eine eigene Färbung.

Die Frage, wer auf meine Gemälde kommt, erhält eine eher technische Antwort dadurch, dass ich noch immer an diesen 10-Dollar-Kursen *downtown* teilnehme. Da gibt es so viele unterschiedliche Aktmodelle, je nach Alter, Ethnie, Geschlecht, Sexualität... Und gerade so wie sich meine stilistischen Entscheidungen ändern, gehen mir, während ich die Figuren aufbaue und male, verschiedene Körperteile verschiedener Modelle durch den Kopf. Nie denke ich an einen Personentyp, es sind immer viele zusammengesetzte.

SB Unser Gespräch läuft ganz von selbst auf einige der eher formalen oder stilistischen Entscheidungen zu, die du bei deinen Gemälden getroffen hast. Über zweierlei würde ich gern mehr erfahren: Einerseits setzt du eine Menge spontane, unkontrollierte Gesten, Pinselstriche, die sehr impulsiv wirken und eine bestimmte Emotion festhalten. Andererseits gibt es Elemente, die das Ergebnis eines sorg-

within that way of having a visual experience unfold and get complicated. And, within that, it's also adding a nuance to the way of interpreting the figures within the work.

The idea of who gets included in my paintings comes from this much more technical origin point, which is that I continue to sit in on just the $10 workshops that happen in downtown. There's always such a diversity of nude models, including age, race, gender, sexuality... And when I'm painting the figure, just the same way that the stylistic choices change, I'm also referencing in my head different parts of different models as I build the figure itself. I'm never thinking of one type of person, it's always a collection of figures.

SB The conversation is maneuvering itself toward some of the more formal or stylistic choices that you make in your paintings. I'm interested in learning more about two things: on one hand, you use a lot of spontaneous unrestrained gestures, brush strokes that seem to be very impulsive, capturing a certain emotion. And on the other hand, there are elements that are the result of a meticulous, very precise, almost technical geometric process of patterning using computer generated imagery which you then project onto the work. What I find fascinating is, there's a point where I no longer see what came first and what came next and what's the foundation for the other. What is the process of creating that surface and the composition of the work, this kind of dialog between analog and digital, the movement of your hand and the imprint of a machine?

CQ When I go to a canvas, it's always this raw canvas that I treat very minimally but has the effect of a raw canvas. I don't have any sketches or anything before starting a painting. But I have this ongoing practice of drawing figure from life, of building this gestural memory. A lot of the painting is about the memory, or memory of drawing the figure, and even the choices for what environment they exist within, or what patterns exist within it.

fältigen, überaus präzisen, fast technisch-geometrischen Prozesses der Musterung sind, bei dem computergenerierte Bilder zum Einsatz kommen, welche du dann auf das Werk projizierst. Es fasziniert mich, dass ich ab einem gewissen Punkt nicht mehr unterscheiden kann, was zuerst und was später kam und was hier jeweils die Grundlage des andern ist. Wie geht dieser Vorgang der Herstellung von Oberfläche und Bildkomposition vonstatten, dieser Dialog zwischen dem Analogen und dem Digitalen, die Bewegung deiner Hand und der Output einer Maschine?

CQ Wenn ich mich an eine Leinwand begebe, ist es immer diese unbehandelte Fläche, ich bearbeite sie nur ganz minimal, sie hat noch immer die Anmutung einer rohen Leinwand. Ich habe keine Skizzen oder sonstwas, bevor ich mit dem Malen beginne. Aber ich habe diese fortgesetzte Praxis, Figuren nach dem Leben zu malen und dieses gestische Gedächtnis aufzubauen. In meinem Malprozess geht es oft um Gedächtnis, um die Erinnerung ans Zeichnen der Figur und sogar darum, in welcher Umwelt sie existieren und welche Muster es dort gibt.

Wenn ich arbeite, gibt es immer diese ganz physische Beziehung zum Größenempfinden meines eigenen Körpers. Auch das geht auf einen Lehrer zurück, den ich als Teenager gehabt habe, Mr. Gatto. Wenn wir gezeichnet haben, durften wir in den ersten fünf Minuten eines zwanzigmütigen Posierens des Modells überhaupt keine Materialien verwenden, nur unsere leeren Hände. Wir sollten so tun, als ob wir den Akt zeichneten, was sich verrückt anhört, aber wirklich gute Gründe hat. Wir trainierten das Muskelgedächtnis, indem wir die Figur wieder und wieder zeichneten, ohne irgendwas wirklich festzuschreiben. Er lehrte uns auch, falls wir einen Fehler machen, ihn nicht auszuradieren. Denn dann hättest du erst einen falschen Strich gezeichnet und würdest ihn mit dem Radierer noch einmal nachzeichnen, also wiederholen. Zeichne lieber den richtigen Strich neben den falschen.

Beides, das Konzept des Muskelgedächtnisses, aber auch das, einen falschen Strich

When I'm working, it is always this physical relationship to my own sense of scale of my own body. This also goes back to that same teacher that I had when I was a teenager, Mr. Gatto. When we would draw, for the first 5 minutes of a 20-minute pose, we weren't allowed to use any materials at all, just our hands with nothing in them and pretend that we were drawing the figure, which seemed crazy, but the reasoning behind it was actually really sound. But it was also to drill into us this idea of muscle memory, drawing the figure again and again before actually laying down any material. He also told us, if we made a mistake, not to erase that, because then you'll have drawn the incorrect mark first and then you've drawn it again with the eraser, and so you're more likely to repeat it. Just draw the correct mark next to the incorrect mark.

Both that idea of muscle memory, but also of not correcting an incorrect mark, that's something that I use to build the figure. I'll lay down marks with an intention based on muscle memory. I've got a pretty quick hand, but I spend a lot of time interrupting my process of painting and just looking at what I've painted. I'm always challenging myself to observe a more dynamic pose or composition than what I would have done if I was just relying on muscle memory. So it's an interplay between an intended set of marks and then what actually happens, a process of observing what's happening, course correcting and making a new set of intentions based on what is actually happening. I think that leads to a final product that is very difficult to see the beginning and the end of.

When I start to have the figures come into focus, I photograph the work and bring it into the computer. And then I play around a lot with the patterns and with the environment and the planes that bisect the figures.

It's the same back and forth between this idea of intended mark making and then what actually happens, because on the computer, that

nicht zu verbessern, beherzige ich, wenn ich eine Figur aufbaue. Ich folge, auf Grundlage meines Muskelgedächtnisses, einer ganz bestimmten Absicht und bringe entsprechend Pinselstriche an. Meine Hand ist an sich ziemlich flink, doch verbrauche ich viel Zeit damit, den Malprozess immer wieder zu unterbrechen und mir anzuschauen, was ich da gemalt habe. Ich fordere mich selbst damit heraus, einer dynamischeren Pose oder Komposition zu folgen als derjenigen, die ich gemacht hätte, hätte ich mich nur auf das Muskelgedächtnis verlassen. Es ist also ein Hin und Her zwischen einer beabsichtigten Folge von Strichen und dem, was sich wirklich abgezeichnet hat, einer Beobachtung dessen, was passiert, einer Kurskorrektur und dem Entwerfen neuer Absichten, die auf dem beruhen, was sich gerade ereignet. Das führt zu einem Endergebnis, in dem nur sehr schwer Anfang und Ende zu erkennen sind.

Sobald sich die Figuren herausschälen, fotografiere ich das Werk und speise es in den Computer ein. Und dann spiele ich viel mit den Mustern und mit der Umgebung und mit den Ebenen, die die Figuren durchschneiden, herum. Es ist dasselbe Hin und Her wie bei dem absichtlichen Strich und dem, was wirklich passiert ist, denn auf dem Computer treten ebensoviele Fehler und Störungen auf. Und ich finde den Computer sehr hilfreich dabei, das Größenverhältnis aufzuheben, denn so viel von meiner Arbeit hängt von meinen Körpermaßen ab. So füge ich den Gemälden ein Element bei, das vom physischen Maßstab unabhängig ist.

SB Du fertigst großformatige Gemälde an, aber du schaffst auch all diese schönen, vergleichsweise kleinen Papierarbeiten. Wenn wir über Muskelgedächtnis und das Verhältnis deines Körpers zur gegebenen Oberfläche sprechen, ist das eine vollkommen andere Geste: die körperliche Arbeit, die du in ein Gemälde steckst, und die viel mehr zurückhaltenden und kontrollierten Bewegungen, die in dein grafisches Werk eingehen. Wann ist dir nach Malen, wann nach Zeichnen? Und warum gibt es handschriftliche Erklärungen und

can be just as many moments of mistakes and glitches. And I find that the computer is a really helpful way of breaking up scale for me because so much of my work is dependent on the scale of my own body. It's a way of creating an element to the paintings that's not so bound to physical scale.

SB You do large-scale paintings and then you create all these beautiful works on paper that are very small in comparison. Talking about muscle memory and the relationship of your body to the actual surface that you are working on, it's a completely different gesture: the physical labor that goes into making a painting and the much more contained and restrained movements that go into your linear work. When do you need to paint and when do you need to draw? And why are there written statements and words in your drawings, but I don't think I've ever seen them in the paintings?

CQ In earlier paintings I have used written text, but not since around 2016.

It all comes back to the same figure drawing teacher I had. He also did talk about this idea of thinking through the actual physical rotation of different joints in your body when thinking through how to render certain lines and that a shoulder socket is going to be much better for doing a circle than your elbow, but your elbow is going to be great for doing a line. Thinking about the physical specificity of parts of my body for rendering certain things is also carried through in the scale of the work. When I work on a painting, it is much more in the shoulder scale of making. The canvases change in size quite a bit but the scale of the figures is always fairly consistent, and it's always consistent with this shoulder wingspan.

The drawings have always been on the same size of paper and with the same size of pen. And it's very much not in the shoulder scale of work, it's much more like this wrist scale. In that way I think of the drawings as being more related to writing in the sense that, when you write down notes or write in a diary, I think of the

Wörter auf deinen Zeichnungen, während ich so etwas auf deinen Gemälden noch nie gesehen zu haben glaube?

CQ In älteren Gemälden habe ich geschriebenen Text verwendet, aber nicht mehr seit ungefähr 2016.

Das geht alles auf den einen Zeichenlehrer zurück, den ich hatte. Er empfahl auch, die tatsächliche Drehung verschiedener Gelenke im jeweiligen Körper zu berücksichtigen, wenn du darüber nachdenkst, wie du bestimmte Linien anlegen sollst, und dass eine Schulterpfanne viel besser für einen Kreis geeignet ist als ein Ellbogen, aber sich der Ellbogen wiederum großartig für eine Linie eignet. Das Nachdenken über die Eignung der physiologischen Besonderheit von Körperteilen für die Darstellung bestimmter Dinge setzt sich auch im Maßstab des Werks fort. Wenn ich an einem Gemälde arbeite, entsteht es vor allem auf Schulterhöhe. Obwohl die Formate der Leinwände sich etwas ändern, bleibt die Größe der Figuren stets ungefähr dieselbe, und sie entspricht der Schulterspannweite.

Die Zeichnungen haben immer dieselbe Bogengröße und werden immer mit einem gleichgroßen Stift angefertigt. Das ist keine Arbeit auf Schulterhöhe, sondern im Bereich des Handgelenks. Darin erkenne ich eine engere Verwandtschaft des Zeichnens mit dem Schreiben, denn wenn du etwas notierst oder in dein Tagebuch einträgst, ist eher das Handgelenk an diesen mentalen Prozess angeschlossen als der ganze Körper.

Bei den Gemälden geht es darum, Gedanken mittels eines sehr körperlichen Vorgangs auszudrücken. Die Zeichnungen dagegen drücken Gedanken mittels eines mentalen oder Denkvorgangs aus. Deshalb haben sie mehr mit dem Schreiben gemein.

Als ich in der Uni zum letzten Mal Text in meine Gemälde eingefügt habe, fiel mir auf,

wrist as being more connected to this thought process rather than physicality. With the paintings, it's about expressing ideas through a very physical process. And with the drawings it's more about expressing ideas through a mental process or a thinking process. That's why there are more instances of writing within it.

In grad school, which was the last time that I included text in my paintings, I noticed that people were really quick to use the text as a way of understanding, as the marker, and I never use text in that way. I was much more interested in it as representing something that wasn't there. Like the word "flower" is not a flower, but it is representative of a flower. I also like the fact that text is very specific, but also open to interpretation. We all can understand "flower" if we speak the same language, but we're probably all thinking of different types of flowers. And so, it's this thing that's public and private at the same time. But I found that whatever text I included, people saw it as the answer to the visual question. We're really uneasy when it comes to visual language. And so I thought that was too misleading for me as a maker to include text that wasn't a caption, but in such a captioning way.

So I took it out of the paintings, and that's really when the patterns started to develop. I found that patterns could serve that same function of being both a shared understanding, but also left to individual interpretation. It also took out the specificity of being an English speaker. Since I still love text and slang and puns and these notations which I keep all around my studio and use for titles of work, I've left text in the drawings. I have also left text in the installations that I do because I find that that is removed enough from the picture plane, becoming a pattern within the room where text can exist.

SB Our life experiences shape us in many ways. The people that we meet, the conversations that we have, the pivotal incidents that we go through in life and clearly, an artist sometimes channels these into what they do. In the last couple of years, you've had some amazingly profound developments in your personal life. You've become a wife, you've become a mother.

dass Menschen sehr rasch den Text als ein Mittel des Verstehens, als Kennzeichnung heranziehen, doch so verwende ich ihn niemals. Ich wollte eher etwas repräsentieren, was nicht da ist. So wie das Wort „Blume" keine Blume ist, aber für eine Blume steht. Ich mag an Text auch, dass er einerseits ganz explizit, andererseits auslegbar ist. Wenn wir dieselbe Sprache sprechen, verstehen wir alle, was „Blume" heißt, aber denken vermutlich an unterschiedliche Sorten von Blumen. Es ist also etwas, das zugleich öffentlich und privat ist. Aber ich musste herausfinden, dass, egal was für einen Text ich aufnahm, die Leute das als Antwort auf die vom Visuellen aufgeworfene Frage auffassten. Es wird uns immer unbehaglich, wenn es um Bildsprache geht. Und so kam es mir als Macherin schließlich irreführend vor, Text einzufügen, der zwar keine Überschrift sein sollte, aber so erscheinen mochte.

Also nahm ich den Text aus den Gemälden heraus, und so begannen die Muster sich zu entwickeln. Ich entdeckte, dass die Muster dieselbe Funktion übernehmen können, zugleich allgemein verstanden zu werden, aber der individuellen Interpretation gegenüber offen zu bleiben. Damit fiel auch die Besonderheit weg, dass ich eine englische Muttersprachlerin bin. Aber da ich weiter Text und Slang und Wortspiele und all diese Notizen liebe, die mich überall in meinem Atelier umgeben und die ich als Werktitel verwende, habe ich Text in den Zeichnungen gelassen. Text habe ich auch in meinen Installationen, weil ich finde, sie sind weit genug von der Bildfläche entfernt und verschmelzen mit dem Raum zu einem Muster, in dem es dann auch Text geben kann.

SB Unsere Lebenserfahrungen prägen uns auf vielerlei Weise – die Leute, die wir treffen, die Gespräche, die wir führen, die wichtigen Ereignisse, durch die wir in unserem Leben gehen –, und eine Künstlerin lässt sie manchmal in ihr Werk einfließen. In den letzten Jahren gab es tiefgreifende Veränderungen in deinem Privatleben. Du bist Ehefrau, du bist Mutter geworden. In welchem Maße haben deinem Eindruck nach diese sehr

To what extent do you feel that these very meaningful developments, probably the most important connections that you have made in your life so far, have impacted the connections that you seek to portray in your work?

CQ I think that the idea of scale has become more interesting to me, especially since becoming a mother. It shifted from this very individual scale to the idea of a continuum of life cycles. I think that the idea of a life cycle really shifts when you suddenly are so invested in somebody in another generation that—best case scenario—is going to very much outlive you. My wife, Alyssa, and I, we were talking about how our daughter could potentially live into the next century and how crazy that is. It's also this way of shifting identity markers that feel so solid in your own life. As soon as I became a parent, my mother became a grandparent. I think that bringing a child, and especially a first child, into a family, it just shifts this wheel of roles. That cyclical nature and complex relationship to time is something that for me has become more apparent.

As an artist, so much of your life is spent in isolation in the studio doing something that you're fully invested in when you're there. So much of what is great about making art is that you're doing something where you have to be very in the moment and you're very present, you're so absorbed with it, you can only do that thing. And it's been interesting to experience something that I'm so familiar with in the studio, but in isolation, and then doing that with another person, or in a community of people. It's interesting to experience something that's so absorbing, that takes all your focus and attention, and how you have to constantly be shifting and readjusting. All these things I'm so used to doing alone in the studio, but then doing that in a community of people with raising a child.

SB Let's talk about Berlin. You've had some really beautiful and substantial presentations of your work in other institutions and this is clearly a continuation. It's your first solo presentation in an institutional con-

bedeutenden Verbindungen, vielleicht die wichtigsten in deinem bisherigen Leben, die Verbindungen beeinflusst, die du in deinem künstlerischen Werk porträtieren willst?

cq Insbesondere seitdem ich Mutter bin, haben mich die Maßgaben mehr beschäftigt. Das Denken ging von den ganz individuellen Maßen über zum Gedanken eines Kontinuums der Lebenszyklen. Über den Lebenszyklus denkst du anders, wenn du plötzlich so intensiv mit einer anderen Generation zu tun hast, die – den günstigsten Fall angenommen – dich lange überlebt. Alyssa, meine Frau, und ich sprachen darüber, dass unsere Tochter das nächste Jahrhundert erleben könnte und wie verrückt das ist. Auf diese Weise verschieben sich Identitätsmerkmale, von denen du gedacht hast, sie blieben in deinem Leben für immer gleich. In dem Moment, in dem ich ein Elternteil wurde, wurde meine Mutter Großmutter. Wer ein Kind, vor allem ein erstgeborenes Kind in eine Familie bringt, dreht dieses Rad der Rollen weiter. Die zyklische Natur und das komplexe Beziehungsverhältnis von Zeit ist etwas, das für mich immer deutlicher wurde.

Als Künstlerin verbringst du so viel Zeit deines Lebens isoliert in deinem Atelier und tust etwas, dem du dich voll und ganz hingibst, solange du da bist. Großartig am Herstellen von Kunst ist insbesondere, dass du bei dem, was du tust, völlig im Moment, sehr präsent und so davon erfüllt bist, dass du nur diese eine Sache tun kannst. Und es ist eine interessante Erfahrung, etwas, mit dem ich sehr vertraut bin, aber alleine im Atelier, mit einer andern Person oder mit einer Gruppe von Personen zu erleben. Es ist interessant, so vereinnahmt zu werden von etwas, das all deine Konzentration und Aufmerksamkeit in Anspruch nimmt, und wie du dich dabei ständig anpassen und neu einstellen musst. All diese Dinge, die ich bislang allein im Atelier getan habe, aber nun in Gemeinschaft mit Menschen tue und dabei ein Kind großziehe.

sb Lass uns über Berlin sprechen. Es gab schon eine Reihe schöner und beacht-

text in Germany and one of the first exhibitions since Till Fellrath and I have joined as directors. What are your hopes for this exhibition? It's been a very interesting process because it's your show, but you've also selected works from the collection to be shown in dialog with your work and there's an elaborate architectural installation. Can you tell us a little bit about what's been happening in the last few months from your perspective? As the artist who's invited to do this, having engaged with our collection and everything that's projected onto Berlin, how do you feel?

cq It's so exciting to be able to work on this project because it incorporates so many things that I love doing with a presentation of my work, which is providing these visual ways of expanding on an idea. We can rely—I do it myself—where we want to rely on wall text about how to understand work. But I think one of the beautiful things about art is that it's not bound to this specific linear way of understanding text. It's much more experiencing this thing that is simultaneous, and emotional, and felt. But it's also something that unfolds and changes and can be analyzed. There are all these ways that work could be expanded upon, outside of itself, without just relying on text. A lot of that I'm hoping is going to happen in this presentation, with the way that we've worked through the exhibition design, with the installation that I'm creating for the show and with the works from the collection.

One of the themes that's been emerging for me a lot throughout this process has been this idea of the expanse of a timeline, that then also can collapse into the singular moment of a present.

And I think that a lot of this work that I'm making right now, especially this installation,

licher Ausstellungen deiner Arbeit in anderen Institutionen, die nun von dieser fortgesetzt wird. Es ist deine erste Einzelausstellung in einer deutschen Institution und die erste Ausstellung, seitdem Till Fellrath und ich die Leitung im Hamburger Bahnhof übernommen haben. Welche Hoffnungen setzt du in diese Ausstellung? Es war eine hochinteressante Entwicklung, weil es zwar deine Schau ist, aber du auch Werke aus der Sammlung gewählt hast, die in Dialog mit deinem Werk stehen, außerdem gibt es eine aufwendige Installation. Kannst du uns ein wenig darüber berichten, was aus deiner Sicht in den letzten Monaten vorgegangen ist? Wie fühlst du dich als Künstlerin, die eingeladen worden ist und die sich mit unserer Sammlung und allem, was auf Berlin projiziert wird, beschäftigt hat?

CQ Es ist sehr aufregend, an diesem Projekt arbeiten zu können, weil es in vielerlei Beziehung einen Gedanken visuell vertieft, denn gerade das schätze ich ganz besonders, wenn ich mein Werk ausstelle. Wir können – das tue ich auch selbst – auf Wandtexte zurückgreifen, wenn wir ein Werk verstehen wollen. Aber ich meine doch, zu den schönen Dingen an der Kunst gehört, dass sie nicht auf diese spezielle, lineare Art des Textverständnisses angewiesen ist. Es geht viel mehr darum, dieses Ding zu erfahren, das simultan ist, emotional ist und gefühlt wird. Und es ist durchaus auch etwas, das sich entfaltet, sich verändert und analysiert werden kann. Es gibt so viele Möglichkeiten, ein Werk von außen weiterzudenken, ohne gleich auf Text zurückzugreifen. Vieles davon wird sich bei dieser Präsentation hoffentlich verwirklichen, auch dank der Ausstellungsgestaltung, die wir erarbeitet haben, dank der Installation, die ich eigens für die Schau schaffe, und dank der Werke aus der Sammlung.

Ein Thema, das während des Arbeitsprozesses auftauchte, ist die Verlängerung der Zeitachse, die aber auch auf den einen, gegenwärtigen Augenblick zusammenschnurren, also kollabieren kann. Und ich meine, viele Werke, die ich gerade erarbeite, ganz beson-

has to do with this sort of collapse of space. And I think that bringing forward the work from the collection is a way of working with that opening of space that can happen, but then also the collapsing of history into the present. And I think that the specificity of Berlin is an interesting place to think through this idea of staying cognizant of the present while still being very much aware of history and of the past and of the future. Even the physical location of the museum and the larger implication of a place of transit. This appearance of a train station that the museum has is very interesting to me; the idea of transit and travel as being this weird moment when you're at that crossroads of where you've been and where you're going, and you're in this location where you have to be very aware of your present.

SB I like what you're saying so much because I really think it encapsulates so beautifully a lot of what we have been thinking, discussing, challenging each other about. For me, the way the works from the collection dialog with your work is exactly what you're talking about. It's taking that lineage, it's taking that history, it's collapsing that time and bringing it to the present. Thank you so much for sharing your thoughts with us!

ders die Installation, handeln von diesem Kollabieren des Raums. Wie wir ein Werk aus der Sammlung nach vorn bringen, hat mit der möglichen Öffnung von Raum ebenso zu tun wie mit dem Zusammenfallen der Geschichte im Gegenwärtigen. Berlin eignet sich ideal für das Vorhaben, gleichzeitig das, was gerade passiert, aber auch Geschichte, Vergangenheit und Zukunft im Blick zu haben. Dazu gehört auch der Bau des Hamburger Bahnhofs selbst und die allgemeinere Konnotation, ein Ort des Transit zu sein. Mit ihm verbunden ist die Vorstellung vom Umsteigen und Reisen als dem eigenartigen Moment, in dem du an einem Scheideweg stehst zwischen dem, was du mal warst, und dem, wohin du gehst, und du dich an einem Ort befindest, an dem du genau darauf achten musst, was gerade geschieht.

SB Es gefällt mir außerordentlich, was du sagst, weil es auf sehr schöne Weise viel von dem einfängt, worüber wir gemeinsam nachgedacht, was wir diskutiert und womit wir uns gegenseitig herausgefordert haben. Wie die Werke aus der Sammlung in einen Dialog mit deinen treten, ist genau das, worüber du sprichst. Es fügt sich in diese Linie, es greift diese Geschichte auf, es lässt Zeit zusammenfallen und bringt alles ins Hier und Jetzt. Hab Dank dafür, dass du deine Ideen mit uns geteilt hast!

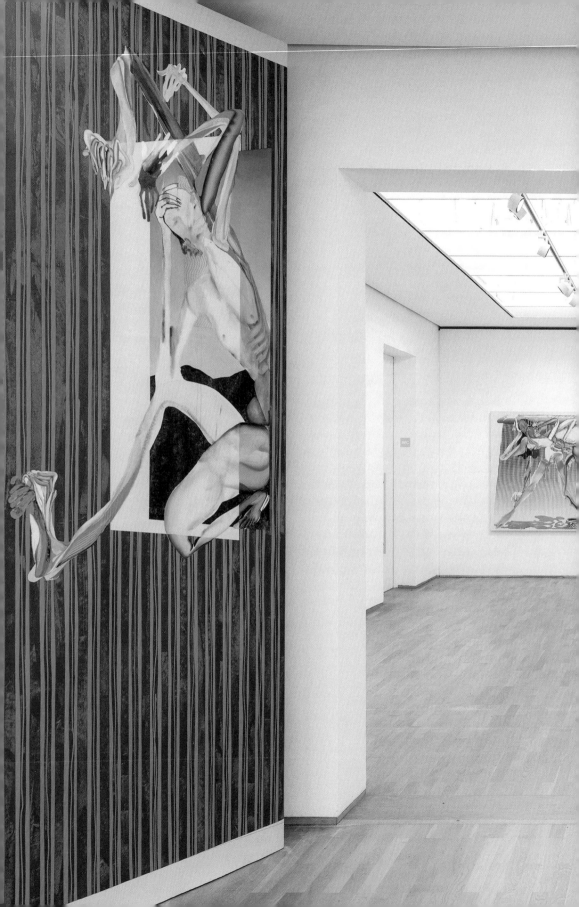

Ausstellungsansicht / installation view *Christina Quarles. Collapsed Time,*
Hamburger Bahnhof – Nationalgalerie der Gegenwart, 2023

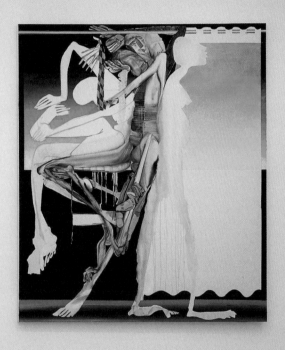

Ausstellungsansicht / installation view *Christina Quarles. Collapsed Time*,
Hamburger Bahnhof – Nationalgalerie der Gegenwart, 2023

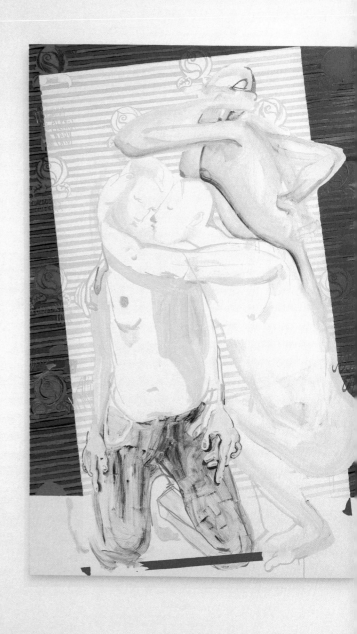

Ausstellungsansicht / installation view *Christina Quarles. Collapsed Time,*
Hamburger Bahnhof – Nationalgalerie der Gegenwart, 2023

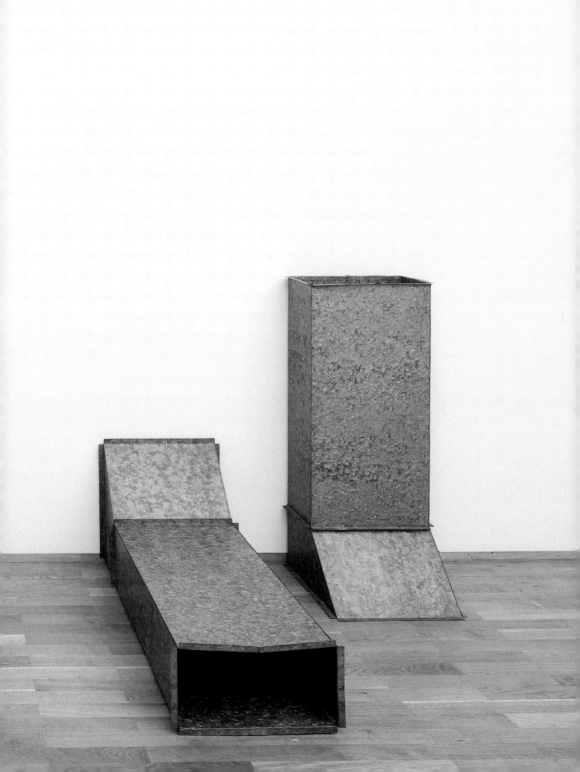

Ausstellungsansicht / installation view *Christina Quarles. Collapsed Time,*
Hamburger Bahnhof – Nationalgalerie der Gegenwart, 2023

Mach ein Fragment aus mir / *Make Me a Fragment*

Jillian Hernandez

Auch wenn sich die Figuren von Christina Quarles nach einer Verbindung sehnen, scheinen sie sich doch in ihrer Fragmentierung eingerichtet zu haben. Von Linie und Textur zusammengehaltene Knäuel aus Fleisch beschwören die Phänomenologie verkörperlichter Subjektivität ebenso herauf wie Traditionen der Körperdarstellung seit der Aufklärung. In einem Interview mit *ARTnews* spricht Quarles darüber, wie sehr ihre Vorgehensweise von ihrem *mixed-race* Standpunkt bestimmt worden sei:

Wir erfahren uns selbst als dieses fragmentierte Bündel von Gliedmaßen, als dieses sich über Tage, ja ein ganzes Leben lang wiederholende Wechseln der

The figures in Christina Quarles's work yearn for connection, but also appear at home in their fragmentation. Knots of flesh tethered together by line and texture evoke the phenomenology of embodied subjectivity and histories of corporeal representation since the Enlightenment. In an interview with *ARTnews*, Quarles describes how her approach to form is shaped by her mixed race positionality, stating:

We know ourselves as this fragmented jumble of limbs and this kind of code switching that happens throughout our lives and throughout our days. A lot of

Sprachebenen. In meine Arbeit fließt viel von dieser Erfahrung des Selbst ein; sie überschneidet sich für mich mit dem Empfinden eines rassifizierten Körpers, nämlich des Körpers von jemandem, der *mixed-race*, halb Schwarz, halb *weiß* ist, aber offenbar von *weißen* Menschen als *weiß* gelesen wird ... Grundlegend für das Werk ist der Versuch, an die Erfahrung dessen heranzukommen, wie es ist, in einem rassifizierten Körper, in einem gegenderten Körper, in einem queeren Körper, wirklich in irgendeinem Körper zu sein und welche Verwirrung das in jemandes Selbstbewusstsein anrichtet.[1]

Die Gemälde von Quarles versuchen weniger, die Knäuel des Körperselbst zu entwirren, um gestisch in Richtung Ganzheit zu streben, sondern erlauben es vielmehr ihren Figuren, an Ort und Stelle zu verweilen und sogar, ganz vorsichtig, an ihrer zerstückten Körperlichkeit Lust zu empfinden. In der Feststellung, dass sie von *Weißen* als *weiß* gelesen wird, zeigt Quarles auf, dass bildliche Darstellung die Wahrheit über ihre ethnische Realität nicht wiederzugeben vermag. Diesem Problem begegnete auch Adrian Piper, die als hellhäutige afroamerikanische Frau von *Weißen* ebenfalls oft als *weiß* wahrgenommen wird und dies in verschiedenen Projekten thematisiert hat. So überreichte sie zum Beispiel immer dann, wenn in ihrer Gegenwart, in der Annahme, sie sei *weiß*, abfällig über Schwarze gesprochen wurde, ihren Gegenübern eine Visitenkarte, die ihre wahre Identität enthüllte. Das Visuelle ist also die Ebene, auf der diese Künstlerinnen durch die Missdeutung ihrer Körper eine Störung

the work is trying to tap into that experience of the self, and then, for me, it's about overlapping that with what it is to be in a racialized body as somebody who's multiracial and who is half Black but is also half white and is legibly seen as white by white people...The basis of the work is trying to get at what it is to be in a racialized body, to be in a gendered body, to be in a queer body, really to be in any body and the confusing place that that actually is with knowing yourself.[1]

Rather than attempt to untangle the knot of knowing the embodied self by gesturing toward wholeness, Quarles's paintings allow figures to linger and even locate tenuous pleasures in their piecemeal carnality. In noting how she is read as white by others, Quarles points to the failure of the visual to convey the truth of her racial identity, a problem artist Adrian Piper also confronted as a light-skinned African American woman who was often perceived as white, leading her to projects such as distributing calling cards revealing her identity to people who had made anti-Black statements in her presence because they assumed she was white. The register of the visual is both where these artists have encountered a breakdown

1 Claire Selvin, „Christina Quarles on the Intricacies of Figuration and Selfhood: ,We Know Ourselves as This Fragmented Jumble of Limbs", in: *ARTnews.com* (Blog), 15.04.2021 (letzter Abruf 13.02.2023).

1 Christina Quarles in "Christina Quarles on the Intricacies of Figuration and Selfhood: 'We Know Ourselves as This Fragmented Jumble of Limbs,'" interview by Claire Selvin, *ARTnews.com* (blog), April 15, 2021. "https://www.artnews.com/art-news/artists/christina-quarles-artist-interview-1234589606/"

des Intersubjektiven haben erleiden müssen. Das Visuelle ist zugleich der Ort, an dem sie die Problematisierung genau der Sichtweisen strategisch entwickeln und ausprobieren, welche die Mythen von ethnischen Unterschieden und Authentizität überhaupt erst in die Welt gesetzt haben. Von besonderem Interesse für die Arbeit von Quarles sind Mythen, die sich in fragmentierten Körperdarstellungen niedergeschlagen haben.

Das Jahrhundert nach der Aufklärung wollte den rassifizierten und gegenderten Körper erkennen und eingrenzen und stützte sich zu diesem Behuf auf eine Bildproduktion, die ihn in Teile und Datenpunkte zergliederte; das sieht man insbesondere auf Fotografien und medizinischen Abbildungen. Die Anthropometrie des im 19. Jahrhundert einflussreichen Kriminologen Cesare Lombroso bezog sich beispielsweise auf die Vermessung der Hüften, Schädel und sogar Labien europäischer Frauen, um so biologische Abweichungen ausfindig zu machen, die erklären sollten, weshalb diese Frauen das gewöhnliche Gender-Schema durchbrechen. Asymmetrie der Gesichtszüge, ein Mangel an idealer Schönheit, Maskulinität und *Blackness* wurden oft mit Straftatbeständen wie Lesbischsein, Sexarbeit und sogar Mord in Zusammenhang gebracht. In einer Zeit, in der westliche Staaten auf kolonialistische Eroberungszüge ausgingen, in einer Zeit auch, in der infolge des Kapitalismus, nämlich durch Industrialisierung und Urbanisierung, die patriarchalische Kontrolle der Bewegungsfreiheit der Frau und ihrer Wünsche sich deutlich erschwerte, sollten Wissensformationen in Medizin und Sozialwissenschaft Ängste vor der weiblichen Sexualität schüren. Ihr wurde nachgesagt, sie untergrabe, ja zerstöre die Strukturen von Familie und bürgerlicher Gesellschaft (die sich auch als Gesellschaftskörper im Sinn von Michel Foucaults Biopolitik versteht). Hier kommt eine weitere Ansammlung geschlechtsspezifischer Körperfragmente in den diskursiven Einsatz: die rassifizierte Frau.

Der Kulturhistoriker Sander Gilman hat in einer wegweisenden Studie zu medizinischer Illustration und Bildender Kunst aufgezeigt,

in intersubjectivity as their bodies have been misread, and also the site where they process and experiment with strategies for problematizing the visual schemes that produce myths of racial difference and authenticity in the first place. Such myths have a particular history of representing the body via fragmentation that is of interest to Quarles's practice.

Post-Enlightenment era projects to know and contain the racialized and gendered body relied upon image production that divided it into parts as data points, namely through photographs and medical illustrations. The anthropometry of influential 19th-century Italian criminologist Cesare Lomborso, for example, relied upon measurements of European women's hips, craniums, and even labia to find biological differences that would explain their transgressions of gendered comportment. Facial asymmetry, lack of idealized beauty, and proximity to masculinity and Blackness were often linked to acts such as lesbianism, sex work, and even murder. As Western states were undertaking colonial projects abroad, while facing capitalism-induced ruptures in patriarchal controls over women's movements and desires in the context of industrialization and urbanization at home, knowledge formations in the medical and social sciences sought to generate fear of women's sexuality as a degenerative and potentially lethal force to the structures of the family and civil society (also understood through corporeal terms as a social body à la Michel Foucault's *biopolitics*). Here enters another assemblage of gendered body fragments put to work in discourse, that of the racialized woman.

As visual culture scholar Sander Gilman has shown in his groundbreaking study of 19th century medical illustration and visual art, a link was established between European women perceived as sexually deviant—poor and working class women workers, sex workers—with African women, understood in this colonial racist frame as inherently hypersexual.[2] Gilman persuasively argues that figures such as the attendant in Edouard Manet's *Olympia* (1863), and myriad other Black servant figures in popular visual culture and art of the time, marked a particular scene as one of illicit sex-

dass im 19. Jahrhundert eine Verbindung zwischen europäischen, als sexuell abweichend gesehenen Frauen – Arme, Berufstätige aus der Arbeiterklasse, Sexarbeiterinnen – und Afrikanerinnen hergestellt wurde, die im rassistischen Kolonialschema als von Natur aus hypersexuell galten.[2] Überzeugend führt Gilman aus, dass solche Figuren wie die Dienerin auf Édouard Manets *Olympia* (1863) und unzählige andere Schwarze Assistenzfiguren in der populären Bildkultur und Kunst der Zeit Szenen markieren, die unerlaubte Sexualität und die Übertretung von Gender-Normen zeigen. Solche Bilder sollten junge Damen davor warnen, den erotischen Unterwelten der modernen Gesellschaft zu verfallen. Die Gesäßbacken afrikanischer Frauen, von der Fantasie europäischer Wissenschaftler enorm überzeichnet, standen im Mittelpunkt sexueller, geschlechtlicher und rassistischer Differenz. Sie wurden dem Körper der abweichenden europäischen Frau semiotisch und darstellerisch angefügt, so als handelte es sich um ein inkorporiertes Fragment; der Hintern als Prothese wie auf Manets Spätwerk *Nana* (1877), oder bei Kim Kardashian.

Grafiken und Illustrationen der fragmentierten Leiber afrikanischer Frauen waren während des 19. Jahrhunderts stark verbreitet. Körperformen wie die von Sarah Baartman, einer vom Ostkap Südafrikas stammenden Angehörigen der Khoikhoi, wurden Europäer*innen öffentlich halbnackt dargeboten – eine Gelegenheit, ihren Körper zu konsumieren, der als Beweis für menschliche wie rassisch-sexuelle Differenz zu gelten hatte. Zeitgenössische Karikaturen halten fest, wie weibliche und männliche Gaffer Baartmans Gesäßbacken und Genitalien anstarren und dabei Ekel, Neugier und Kitzel verspüren. Diese visuelle Fragmen-

uality and gender nonconformity. Such images often served as cautionary tales against young women falling into the erotic underworlds of modern society. The buttocks of the African woman, imagined in hyperbolic terms by European male scientists, served as a primary object of sexual, gender, and racial difference, and were semiotically and representationally attached to the deviant European woman's body as an incorporated fragment, the ass as sexual prosthesis—as in Manet's later work *Nana* (1877), or Kim Kardashian.

Diagrams and illustrations of African women's fragmented bodies circulated widely in the 19th century, and figures such as Sarah Baartman, a woman from the Khoekhoe tribe born in the Eastern Cape of South Africa, were presented semi-nude in public settings to offer Europeans an opportunity to consume her body, which was framed as evidence of human difference as racial-sexual deviance. Cartoons depicting audiences' reactions to Baartman's body portray European men and women gazing at her buttocks and genitalia with alternating expressions of disgust, intrigue, and titillation. Such visual fragmentation took a most disturbing, material turn when Baartman's dissected external genitalia and brain were placed on display at various points in the mid-to-late 20th century at the Musée de l'Homme and Muséum National d'Histoire Naturelle in Paris, until her remains were eventually repatriated to South Africa in 2002.[3]

The magnitude of such gendered and racialized violence exceeds any discourse that could offer a neat roadmap to repair for African descendant women in the diaspora, calling instead for a radical revisioning of how we encounter difference, toward a remaking of how we understand the human, structures

2 Sander L. Gilman, „Black Bodies, White Bodies: Toward an Iconography of Female Sexuality in Late Nineteenth-Century Art, Medicine, and Literature", in: *Critical Inquiry*, 12, 1 (Herbst 1985), S. 204–242.

2 Sander L. Gilman, "Black Bodies, White Bodies: Toward an Iconography of Female Sexuality in Late Nineteenth-Century Art, Medicine, and Literature," *Critical Inquiry* 12:1 (Autumn 1985), pp. 204–242

3 Phillip V. Tobias, "Saartje Baartman: Her Life, Her Remains, and the Negotiations for Their Repatriation from France to South Africa," South African Journal of Science 98:3 (March 2002), pp. 107–110: pp. 108–109..

tierung nahm eine verstörende, höchst stoffliche Wende, als im Musée de l'Homme und im Muséum National d'Histoire Naturelle in Paris von Mitte bis Ende des 20. Jahrhunderts die sezierten primären Geschlechtsteile und das Hirn von Baartman öffentlich präsentiert wurden, bis man ihre Überreste im Jahr 2002 nach Südafrika überführte.[3]

Das Ausmaß solcher geschlechtsspezifischen und rassistischen Gewalt sprengt jeden möglichen Diskurs, der einen glatten Weg der Wiedergutmachung für aus Afrika stammende, in der Diaspora lebende Frauen weisen wollte. Stattdessen ist ein völliges Umdenken in unserer Auffassung von Differenz hin zu einem neuen Verständnis des Menschlichen und von sich bildlich und stofflich ausdrückenden Wissens- und Machtformationen gefordert. Diese Schwarze feministische Vorstellung wurde von Theoretikerinnen wie Hortense Spillers und Sylvia Wynter artikuliert, die, wie Alexander Weheliye, ein Forscher im Bereich der Black Cultural Studies, schreibt, den herkömmlichen theoretischen Diskurs über Biopolitik und das „nackte Leben" verließen – um eines komplexeren Begriffs von Handlungsfähigkeit willen. Außerhalb des etablierten Rahmens von Widerstand, in einem radikalen Außen, gebe es einen „leiblichen Überschuss" Schwarzer Körperlichkeit, der zu „Entstellungen von Freiheit" führe.[4]

Personen, die als eindeutig Schwarz gelesen werden, sind weiterhin von rassistischer Entwertung an Leib und Leben bedroht, während das für *mixed-race* Personen, die als *weiß* durchgehen, nicht gilt, die auch nicht, wie Schwarze Körper, einer ständigen Überwachung unterstehen. Die Bild-Geschichte der Abweichung *weißer* und Schwarzer Weiblichkeit und Queerness legt ein relationales Verständnis von rassistischer und genderspezifischer Repression nahe. Dieses Verständnis ist schon seit Jahrzehnten formuliert worden und muss doch erst noch in die Organisation zeitgenössischer politischer Bewegungen eingebracht werden, die sich gegen Rassismus, Patriarchat, Homophobie und Transphobie wenden. Alle Versuche, scharfe Trennungen zu schließen, die sich zwischen marginalisierten

of knowledge, and the formations of power articulated by visual and material means. This Black feminist vision has been articulated by theorists such as Hortense Spillers and Sylvia Wynter, who, as Black cultural studies scholar Alexander Weheliye argues, intervene in theoretical discourses on biopolitics and bare life to complicate notions of agency to account for the "deformations of freedom" that exist outside established frameworks of resistance in the "fleshy surplus" of Black corporealities that could serve as a radical elsewhere.[4]

While subjects read as unambiguously Black continue to face profound risks to their lives due to racist devaluation in a way that biracial subjects who may pass for white do not, as Black bodies are made ever-available for surveillance, the visual history of correlation between white and Black feminine deviance and queerness suggests a relational understanding of racialization and gendering that has been articulated for decades, but has yet to be fully taken up in the organization of contemporary political movements that have arisen to confront anti-Blackness, patriarchy, homophobia, and transphobia. Attempts to forge clear divisions between and among marginalized populations belie a longer, wider history of being made a visual fragment that, although a violent process, might hold potential for serving as points of coalition in difference. To put it another way, what would it mean to be fragments together and reject the project of assimilating to the myth of the subject as knowable and whole, as the figures in Quarles's work appear to do? Such relations can be glimpsed in Quarles's figurations in paintings such as *We Can Require No Less of Ourselves* (2019), as they approach each other tentatively with pursed lips and open hands, with no interest in possession but a being-with.

Reflecting on Quarles's earlier discussion of how her biraciality informs her practice recalls artist and theorist Lorraine O'Grady's landmark essay "Olympia's Maid: Reclaiming Black Female Subjectivity," where she argues:

Gruppen durch sie hindurch ziehen, können nicht über die längere und größere Geschichte hinwegtäuschen, die aus Marginalisierten visuelle Fragmente gemacht hat. Obwohl diese Fragmente Ausdruck eines gewaltsamen Prozesses sind, könnten sie zugleich Punkte sein, an denen sich Koalitionen der Differenz bilden ließen. Anders gesagt: Was würde es bedeuten, wenn wir, so wie es die Figuren in dem Werk von Quarles tun, als Fragmente zusammenkämen und das Ansinnen ablehnten, uns an den Mythos vom Subjekt als eines Erkennbaren und Ganzen anzupassen? Solche Beziehungen zeichnen sich auf Gemälden wie *We Can Require No Less of Ourselves* (2019) ab, deren Gestalten sich mit geschürzten Lippen und offenen Händen einander zaghaft annähern, nicht um die Andere in Besitz zu nehmen, sondern um mit ihr zusammenzusein.

Beim Nachdenken über Quarles' Bemerkung, Angehörige zweier Ethnien zu sein, habe sich auf ihr Werk ausgewirkt, lassen sich schnell Bezüge herstellen zu dem bahnbrechenden Essay „Olmpia's Maid: Reclaiming Black Female Subjectivity" der Künstlerin und Theoretikerin Lorraine O'Grady, in welchem sie schreibt:

Der weibliche Körper ist im Westen kein einheitliches Zeichen. Er hat vielmehr wie eine Münze Vorder- und Rückseite, auf der einen Seite ist er *weiß,* auf der andern nicht-*weiß* oder, prototypisch, Schwarz. Die beiden Körper lassen sich nicht voneinander trennen, auch kann in der westlichen Konstruktion von ‚Frau' ein Körper nicht isoliert vom andern begriffen werden. *Weiß* ist das, was Frau ist, nicht-*weiß* (und hier schlagen sich die Klischees über nicht-*Weiße* nieder) ist das, was sie besser nicht wäre.[5]

The female body in the West is not a unitary sign. Rather, like a coin, it has an obverse and a reverse: on the one side, it is white; on the other, non-white or, prototypically, black. The two bodies cannot be separated, nor can one body be understood in isolation from the other in the West's metaphoric construction of 'woman.' White is what woman is; not-white (and the stereotypes not-white gathers in) is what she had better not be".[5]

Challenging this durable cultural construction might require the undisciplined, queer dissidence of occupying the space of "what she had better not be," for all subjects constructed as other. I do not mean to suggest mixed race subjectives or Black/white alliances as "a fixed identity nor a solution to racial injustice that

3 Phillip V. Tobias, „Sartje Baartman: Her Life, Her Remains, and the Negotiations for Their Repatriation from France to South Africa", in: *South African Journal of Science,* 98, 3 (März 2002), S. 107–110, hier S. 108f.
4 Alexander G. Weheliye, *Habeas Viscus: Racializing Assemblages, Biopolitics, and Black Feminist Theories of the Human,* Durham: Duke University Press 2014, S. 2.
5 Lorraine O'Grady, „Olympia's Maid: Reclaming Black Female Subjectivity", in: Grant E. Kester (Hg.), *Art, Activism, and Oppositionality: Essays from Afterimage,* Durham: Duke University Press 1998, S. 268–286, hier S. 268.

4 Alexander G. Weheliye, *Habeas Viscus: Racializing Assemblages, Biopolitics, and Black Feminist Theories of the Human,* Durham, NC: Duke University Press, 2014, p. 2.
5 Lorraine O'Grady, "Olympia's Maid: Reclaiming Black Female Subjectivity," in: Grant H. Kester (ed.), *Art, Activism, and Oppositionality: Essays from Afterimage,* Durham, NC: Duke University Press, 1998, pp. 268–286: p. 268.

Um diese verkrustete kulturelle Konstruktion anzugreifen, ist von allen, die als Andere konstruiert werden, die undisziplinierte, queere Dissidenz gefordert, gerade den Raum dessen zu erobern, „was sie besser nicht wären". Damit meine ich nicht *mixed-race* Subjektivitäten oder Schwarz/*weiß*-Allianzen „als fixe Identität oder Überwindung der rassistischen Ungerechtigkeit, die in der naiven Losung bestünde: ‚Eines Tages sind wir alle braun und der Rassismus ist passé.'"[6] Vielmehr schließe ich mich der Feststellung der Forscherin auf dem Feld der Ethnic Studies, der Philosophin Daphne Taylor-Garcia, an, dass „*anti-Blackness* die Epidermisierung einer Negation des Ego/Alter-Verhältnisses ist, das die Kolonisierung der amerikanischen Kontinente bedingt hat."[7] Schwerpunkt für Taylor-Garcia ist die rassifizierte und genderspezifische Phänomenologie der *mixed-race* Personen in Nord-, Mittel- und Südamerika. Sie spricht sich für eine dekoloniale Politik aus, die auf den Beziehungen zwischen den *damné(e)s* (den kolonisierten Subjekten) beruht. Solche Beziehungen müssten auf der gegenseitigen Anerkennung der *damné(e)s* basieren, im genauen Gegensatz dazu, dass ihnen Intersubjektivität sonst verweigert worden ist. Denn sie treffen „auf Vorurteile und Feindseligkeit", sobald ihr „kolonisierter/rassifizierter Körper sich mithilfe ihres kritischen Denkens und ihrer Forschungen, ihrer Ästhetik und ihrer nicht in Kernfamilien abzutrennenden Familienstrukturen in weitere Räume ausdehnen will".[8] Diese Ausdehnung der *damné(e)s* in den Raum, in die Möglichkeit eines Selbstbewusstseins und von Intersubjektivität mittels körperlicher, erotischer Mittel, die den Mythos des Ganzen und Authentischen hinter sich gelassen haben, lässt sich an den Figuren des Werks von Quarles immer dann erkennen, wenn sie miteinander in Kommunikation zu treten scheinen – *Liebling, mach ein Fragment aus mir*.

naively argues 'we will all be brown one day and racism will end'".[6] Rather, I share ethnic studies scholar and philosopher Daphne Taylor-Garcia's contention that "antiblackness is the negation of the self/other relationship emergent from the colonization of the Americas that has been epidermalized".[7] Taylor-Garcia centers on the racialized and gendered phenomenology of mixed race subjects in the Americas to argue for a decolonial politics that is rooted in relations between the damnés (the colonized). These relations would center on reciprocal recognition among the damnés in contrast to the denial of intersubjectivity they face, as "when the colonial/racial body seeks to extend themselves in the spaces in which they inhabit through their critical thought and evaluations, their aesthetics, and nonnuclear family formations, they are instead confronted with stereotypes, hostility...".[8] The figures in Quarles's work can be read as articulations of these extensions of the damnés into space, into the possibility of self-knowledge and intersubjectivity through corporeal, erotic means that abandon the myth of the whole and authentic, as they appear to communicate to each other—*darling, make me a fragment*.

6 Daphne V. Taylor-Garcia, *The Existence of the Mixed Race Damnés: Decolonialism, Class, Gender, Race,* Lanham: Rowman & Littlefield 2018, S. 2f.
7 Ebd., S. 3.
8 Ebd., S. 24.

6 Daphne V. Taylor-Garcia, *The Existence of the Mixed Race Damnés: Decolonialism, Class, Gender, Race,* Lanham,Md: Rowman & Littlefield, 2018, pp. 2–3.
7 Ibid., p. 3.
8 Ibid., p. 24.

Werke in der Ausstellung / *Works in the Exhibition* von / *by* Christina Quarles

Drawings

1 Christina Quarles, *Close at Hand,* 2020, 33 x 48,2 / 13 x 19 in., Tinte auf Papier / ink on paper, Maria Seferian

2 Christina Quarles, *Dear, Dear,* 2020, 33 x 48,2 cm / 13 x 19 in., Tinte auf Papier / ink on paper, The Haidas Collection

3 Christina Quarles, *Fer Something Free, They Don't Care What They Pay,* 2020, 33 x 48,2 cm / 13 x 19 in., Tinte auf Papier / *ink on paper,* Collection of Phil Barker

4 Christina Quarles, *How Could We Kno?,* 2021, 33 x 48,2 cm / 13 x 19 in., Tinte auf Papier / ink on paper, Privatsammlung / private collection, New York

5 Christina Quarles, *I Wanna Soak up Tha Sun,* 2021, 33 x 48,2 cm / 13 x 19 in., Tinte auf Papier / ink on paper, George Wells and Manfred Rantner, promised gift to Morehouse College

6 Christina Quarles, *Thru It,* 2020, 33 x 48,2 cm / 13 x 19 in., Tinte auf Papier / ink on paper, Privatsammlung / private collection

7 Christina Quarles, *Twice a Day,* 2020, 33 x 48,2 cm / 13 x 19 in., Tinte auf Papier / ink on paper, Collection of Allison and Larry Berg

8 Christina Quarles, *Yew Got Tha Right Stuff Baby,* 2021, 33 x 48,2 cm / 13 x 19 in., Tinte auf Papier / ink on paper, George Wells and Manfred Rantner, promised gift to Morehouse College

Oh-Woddah-Beayewtiful--Day--ay

BELIEVE
BEL

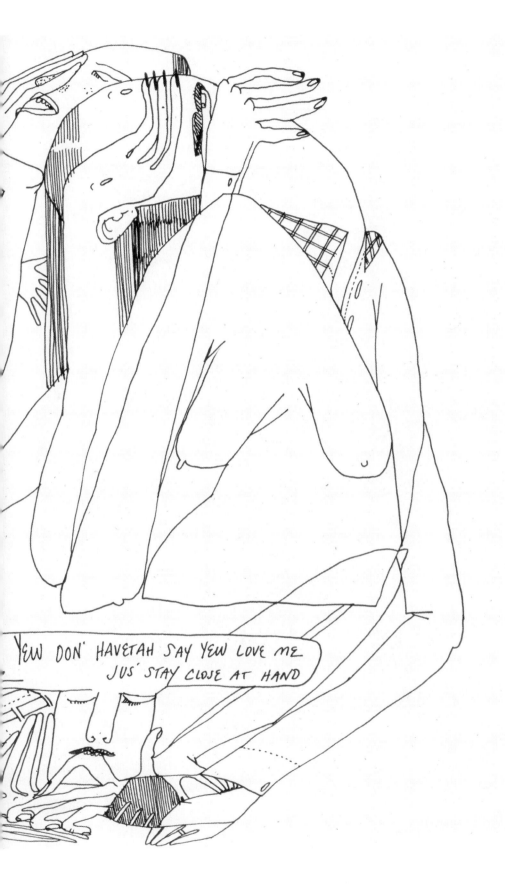

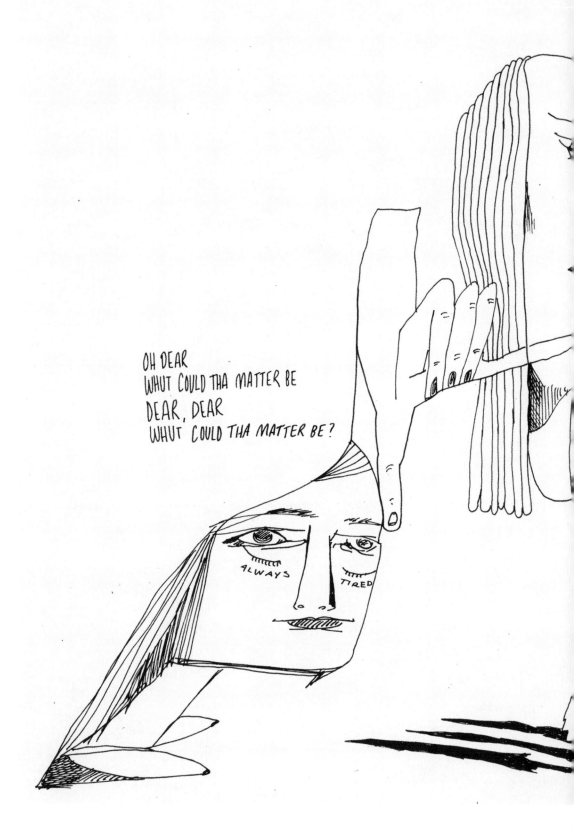

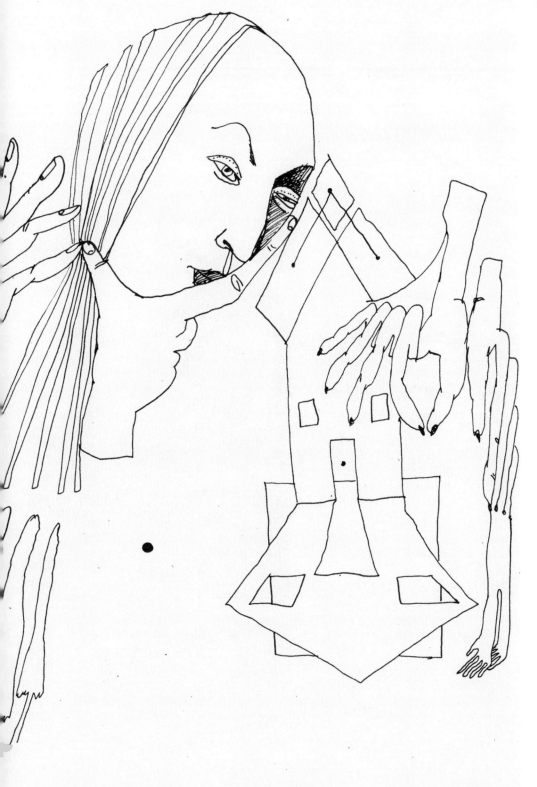

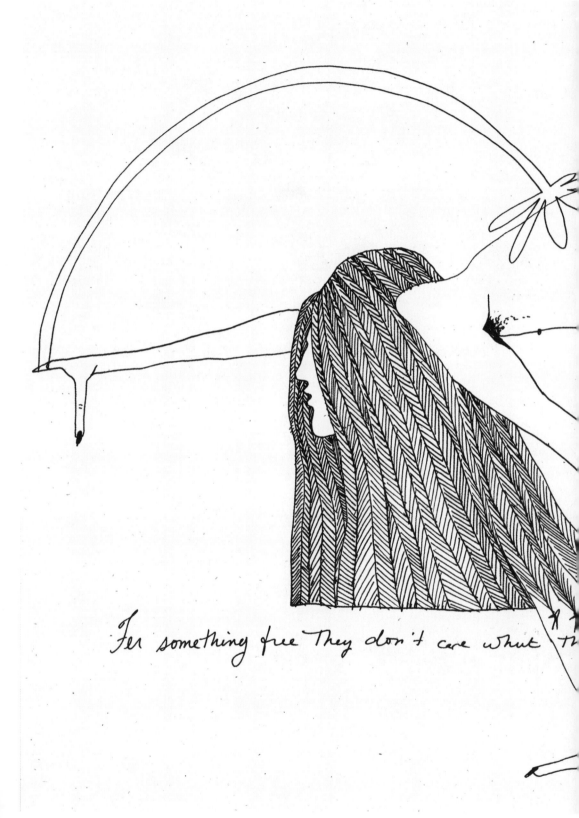

For something free They don't care what th

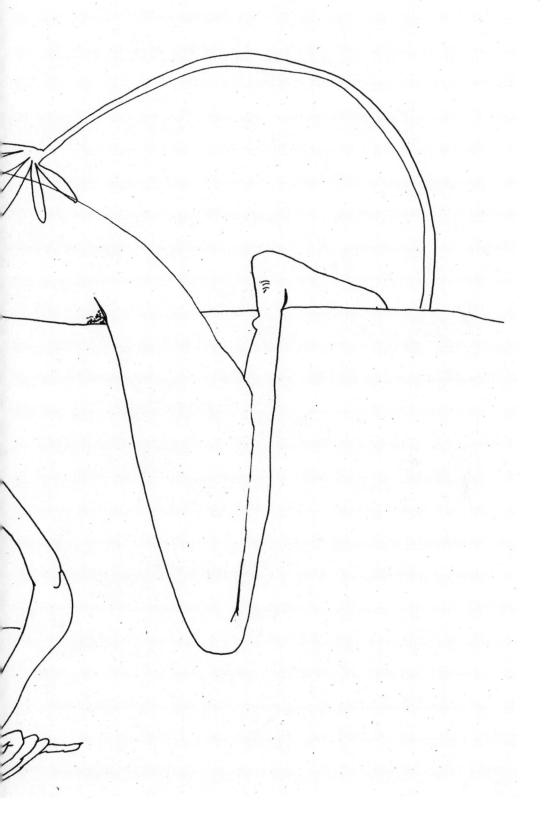

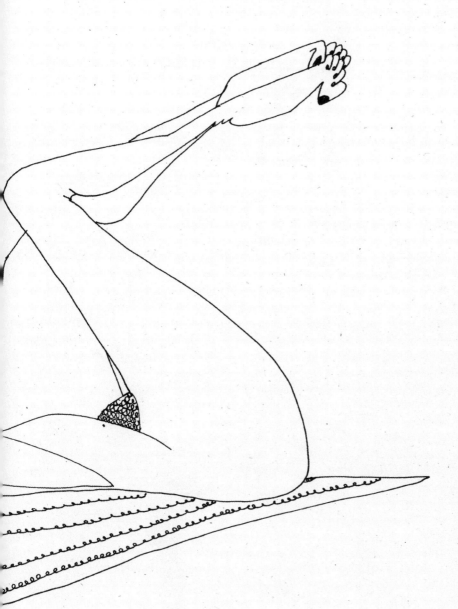

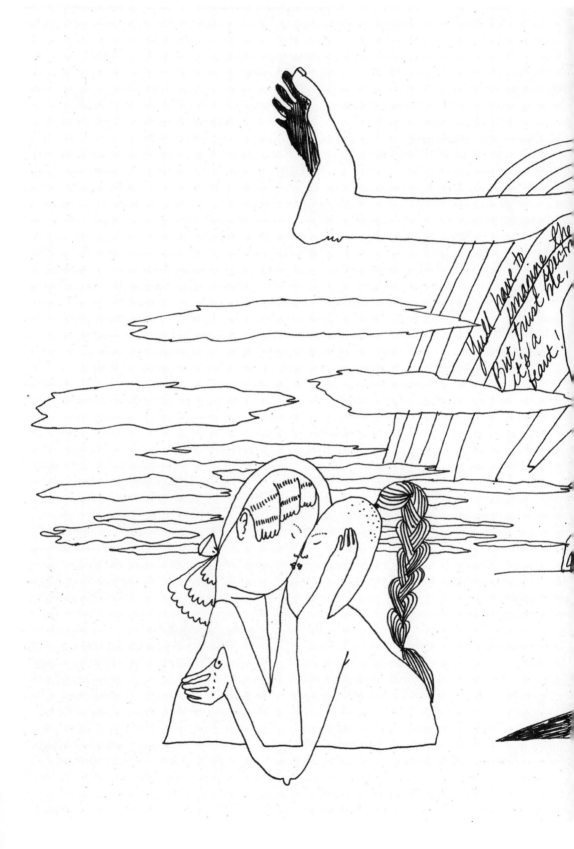

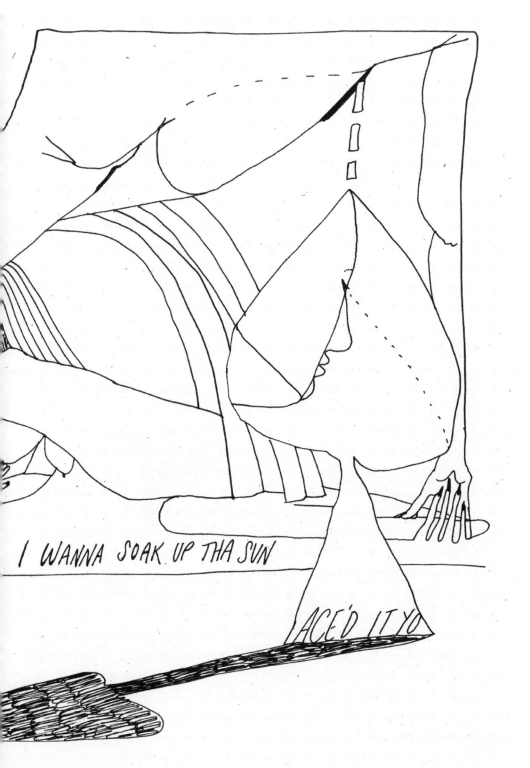

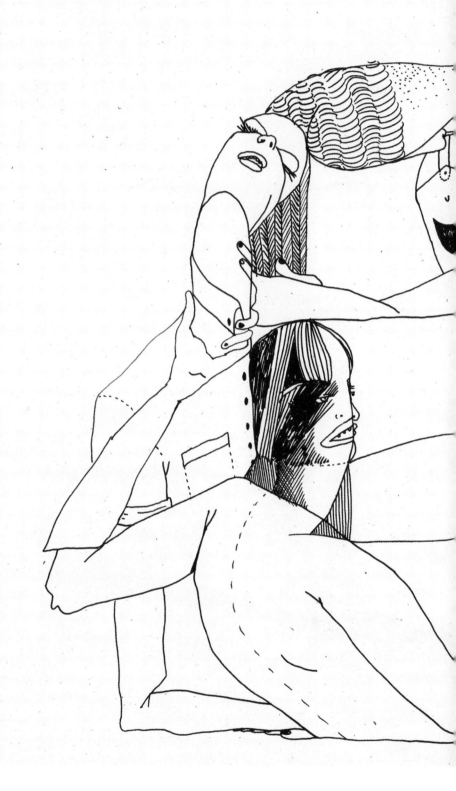

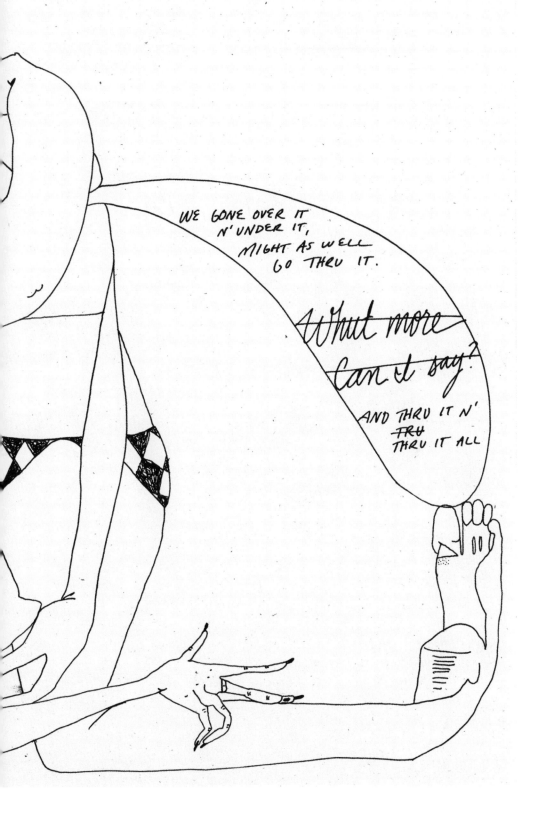

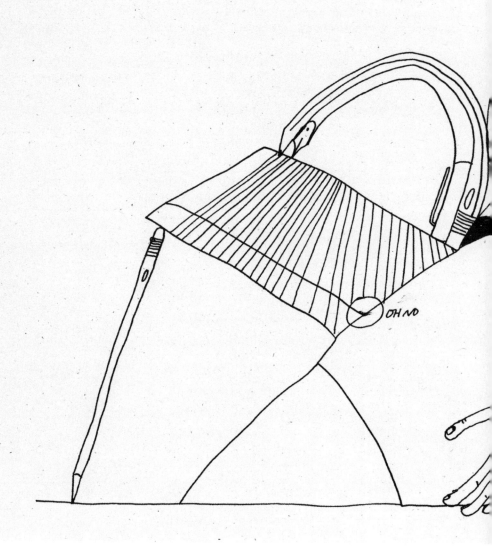

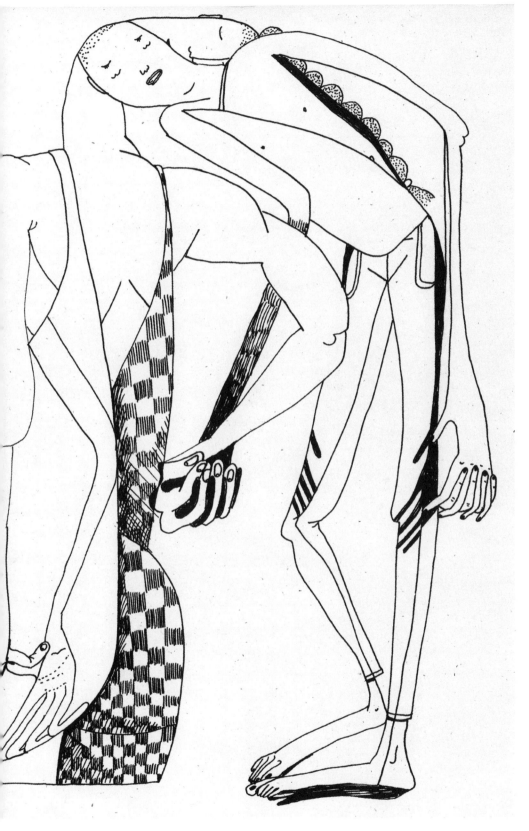

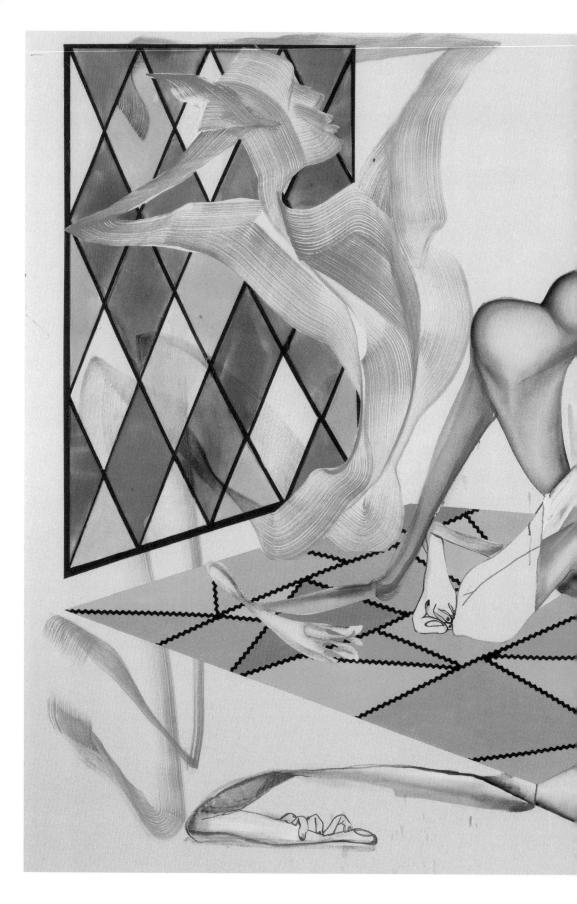

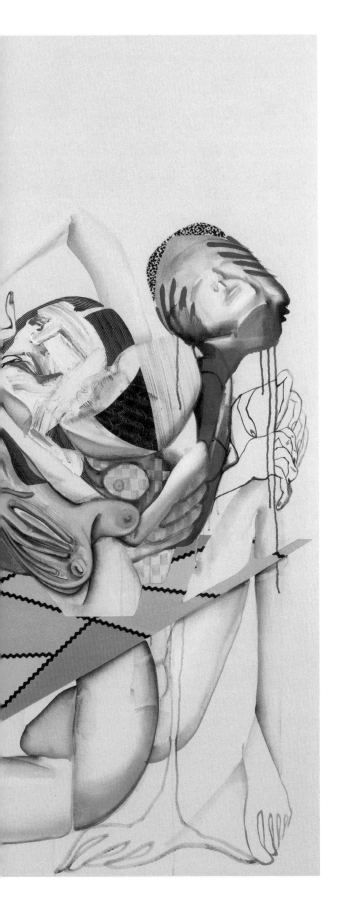

Christina Quarles, *Bless tha Nightn'gale,* 2019, 195,6 x 228,6 cm / 77 x 90 in., Acryl auf Leinwand / acrylic on canvas, Christen Sveaas Art Foundation

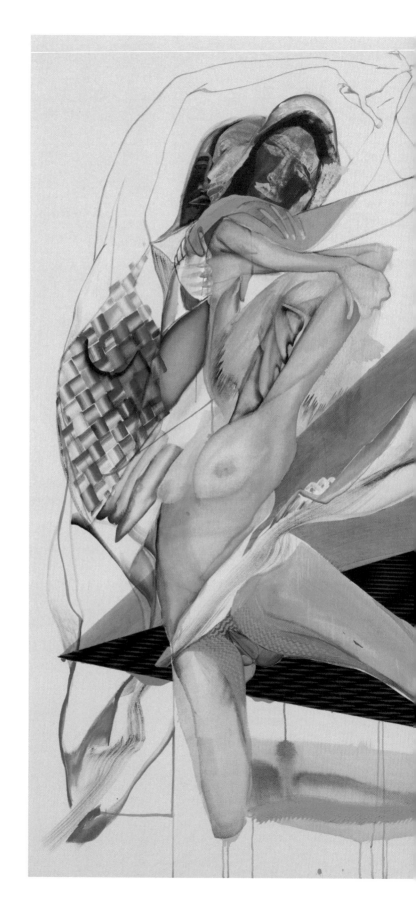

Christina Quarles, *In 24 Days Tha Sun'll Set at 7pm*, 2022, 195,6 x 243,8 cm / 77 x 96 in., Acryl auf Leinwand / acrylic on canvas, Courtesy the artist, Hauser & Wirth, and Pilar Corrias, London

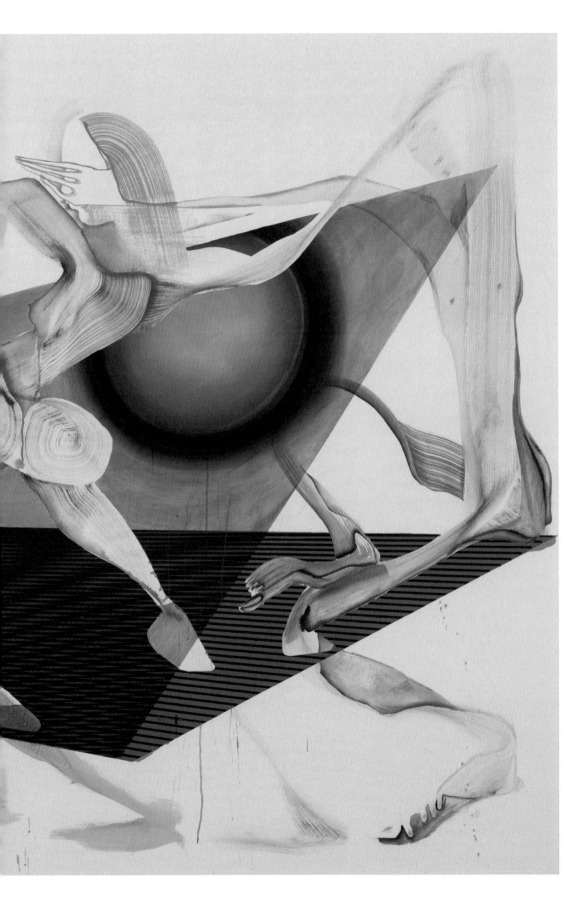

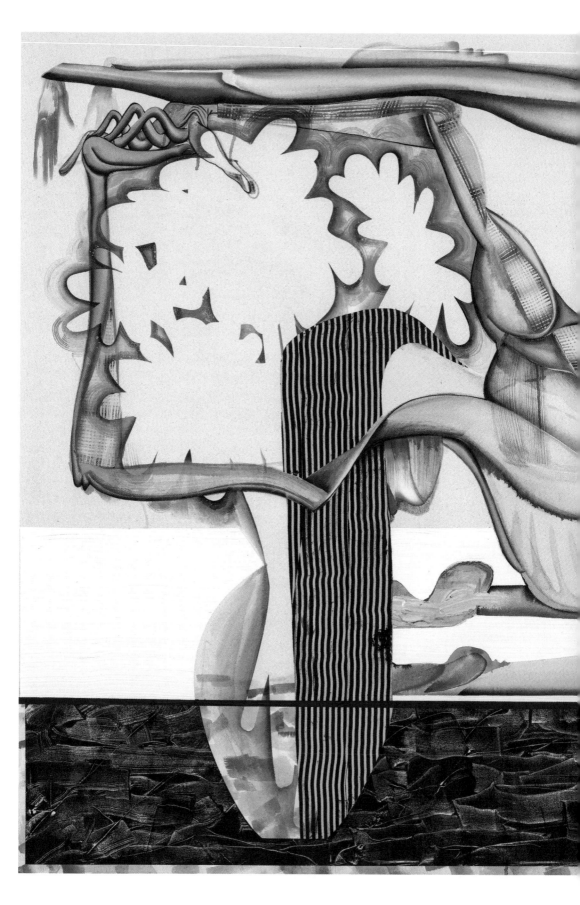

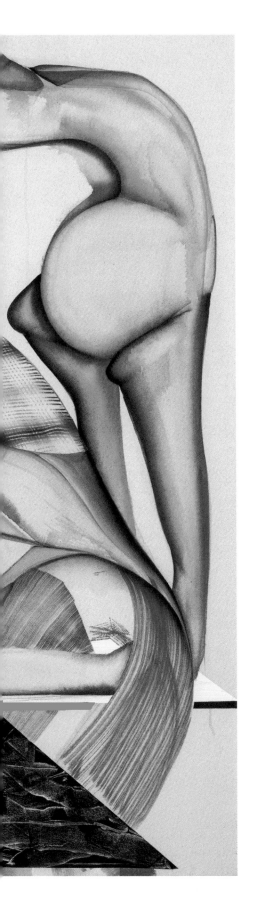

Christina Quarles, *An Absense the Size of Yew,* 2019, 142,2 x 152,4 cm / 56 x 60 in., Acryl auf Leinwand / acrylic on canvas, Collection Joachim and Nancy Hellman Bechtle promised gift for San Francisco Museum of Modern Art

Christina Quarles, *Get Lifted,* 2020,
213,4 x 182,9 cm / 84 x 72 in.,
Acryl auf Leinwand / acrylic on canvas,
Bill Damaschke and John McIlwee

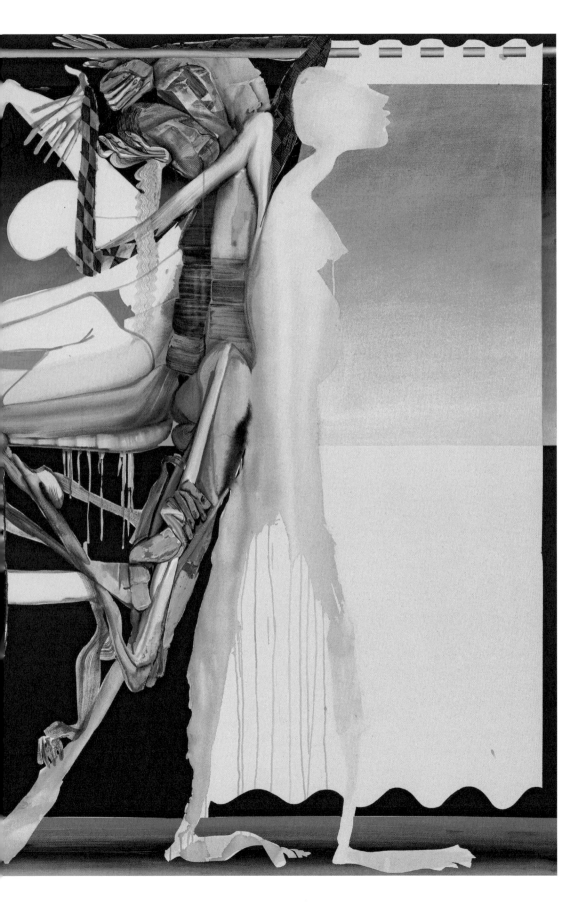

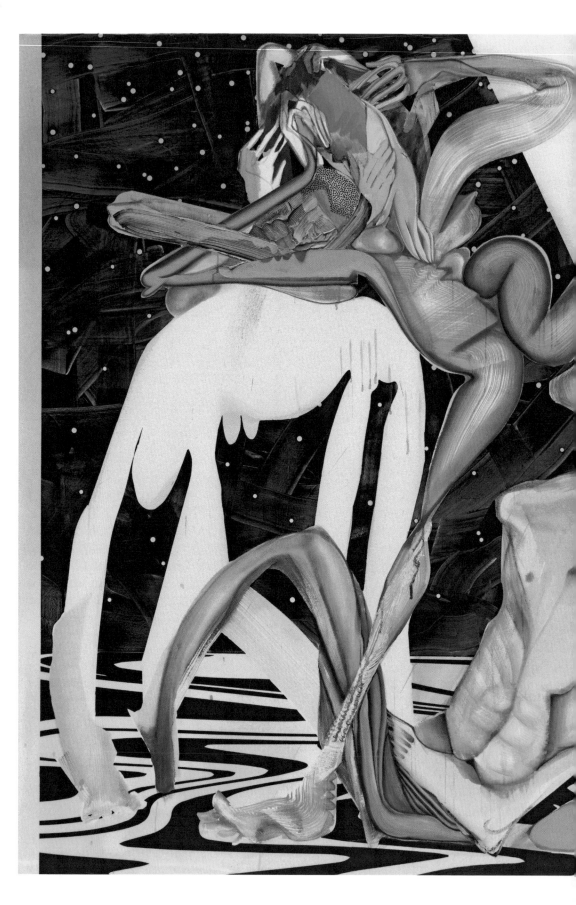

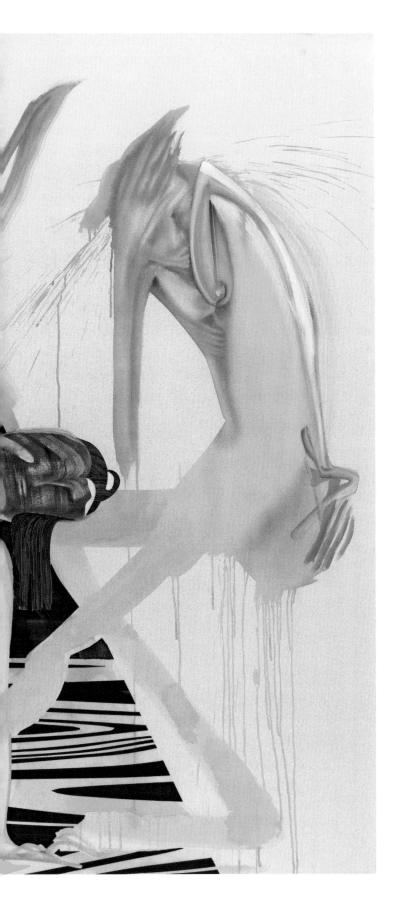

Christina Quarles, *SLICK*, 2022,
195,6 x 243,8 cm / 77 x 96 in.,
Acryl auf Leinwand / acrylic on
canvas, Christie Zhou

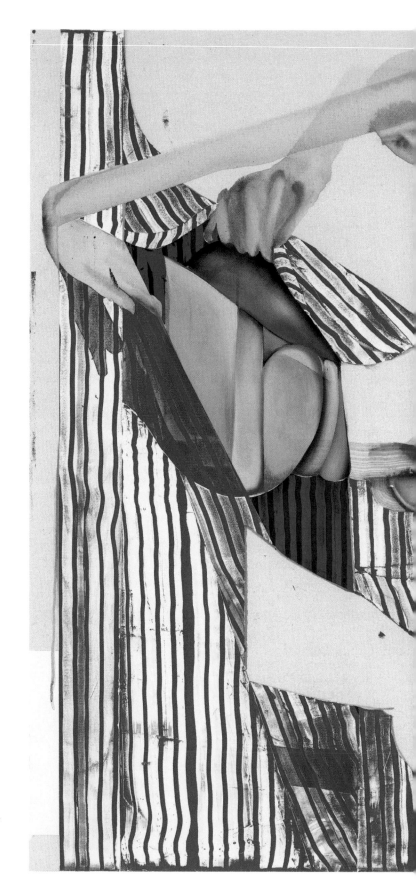

Christina Quarles, *We Can
Require No Less of Ourselves,* 2019,
121,9 x 152,4 cm / 48 x 60 in.,
Acryl auf Leinwand / acrylic on
canvas, Collection of Hedy and
Benjamin Nazarian

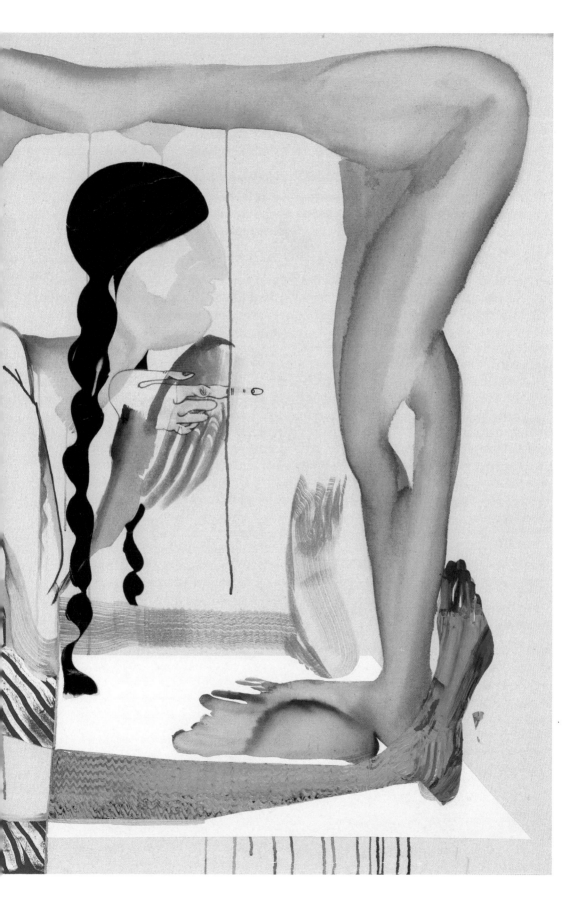

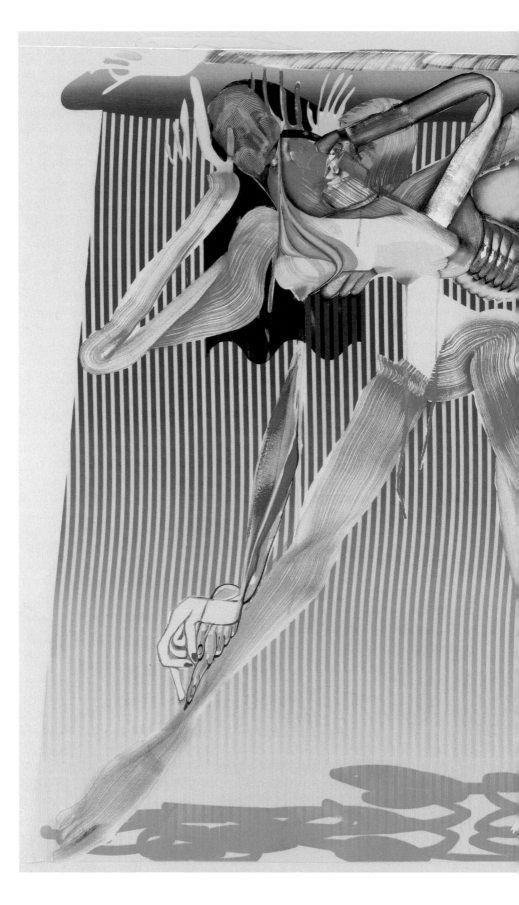

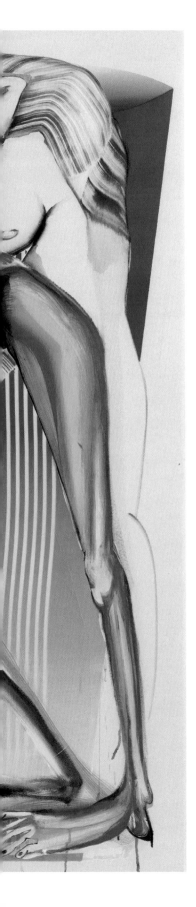

Christina Quarles, *Always (Get Me Down)*, 2021,
167,6 x 157,5 cm / 66 x 62 in., **Acryl auf Leinwand** / acrylic on
canvas, **Privatsammlung** / private collection, **New York**

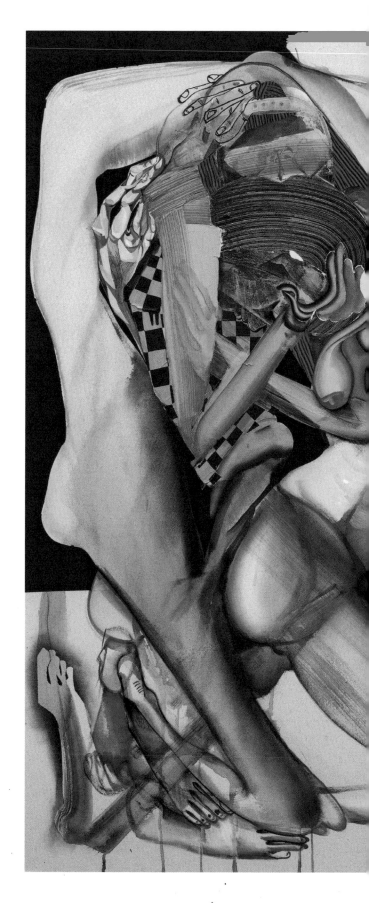

Christina Quarles, *For Whom Tha Sunsets Free,* 2019, 142,2 x 152,4 cm / 56 x 60 in., Acryl auf Leinwand / acrylic on canvas, Courtesy of Christen Sveaas Art Foundation

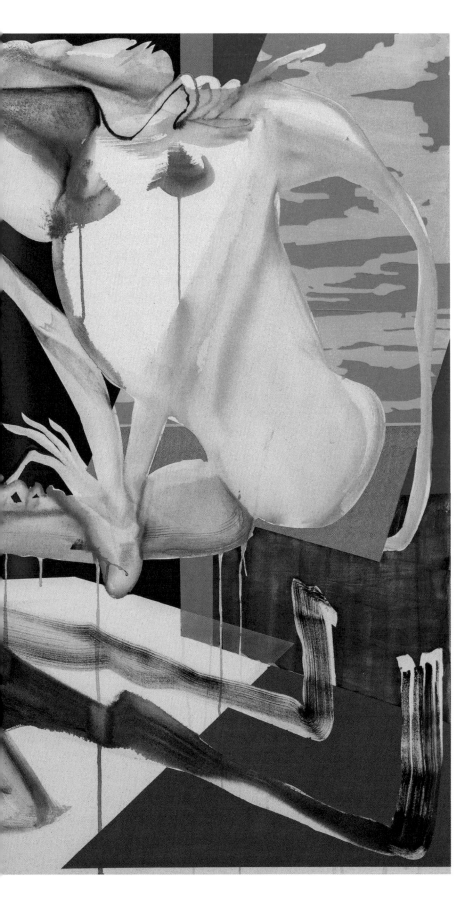

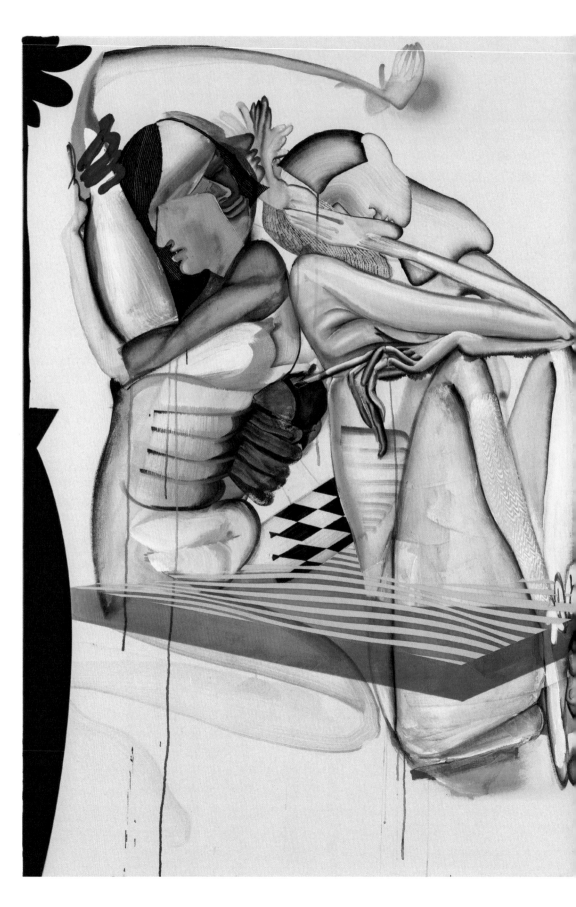

Christina Quarles, *Bad Air/Yer Grievances*, 2018,
157,5 x 139,7 cm / 62 x 55 in., Acryl auf Leinwand / acrylic
on canvas, The Museum of Contemporary Art, Los Angeles,
purchase with funds provided by the Acquisition and
Collection Committee

Christina Quarles, *June Gloom,* 2017, 127 x 142,2 cm
/ 50 x 56 in., **Acryl auf Leinwand** / acrylic on canvas,
Collection of Joey Soloway

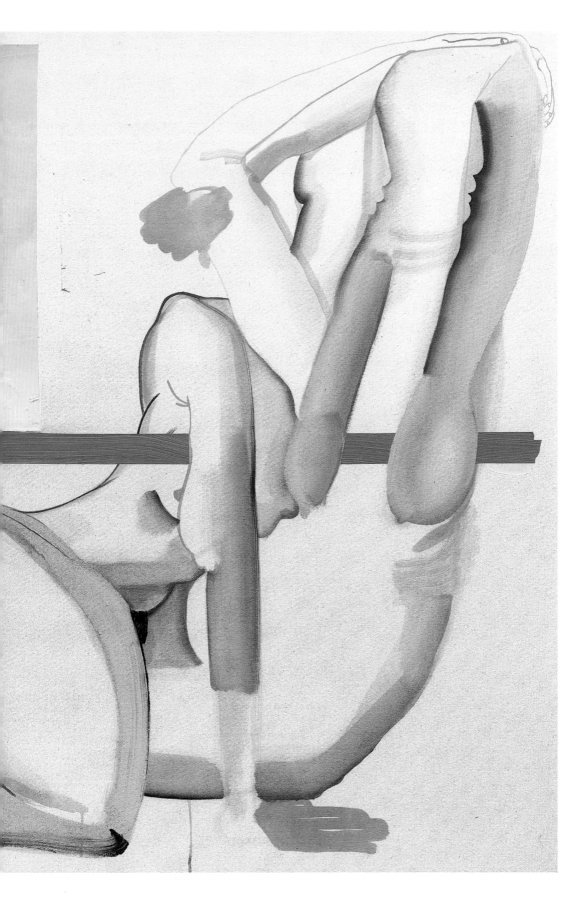

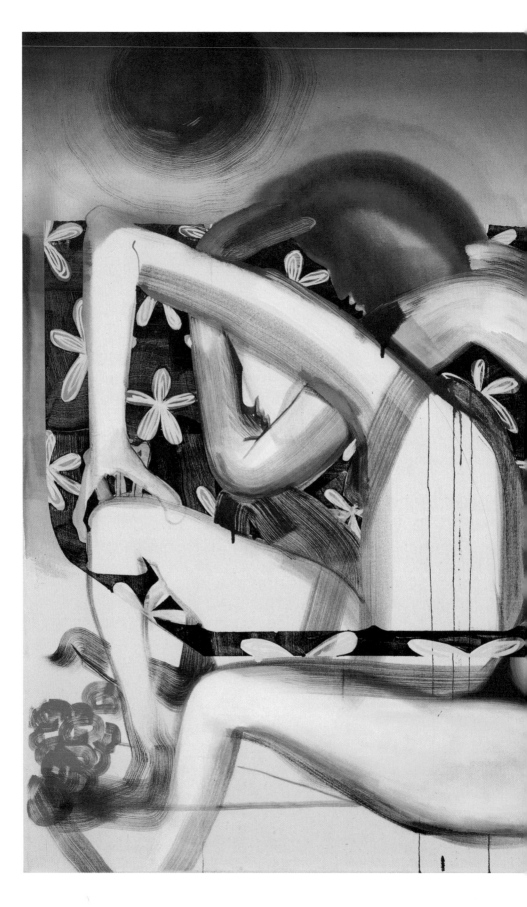

Christina Quarles, *Vulgar Moon,* 2016,
127 x 101,6 cm / 50 x 40 in., Acryl auf Leinwand
/ acrylic on canvas, Collection of Josef
Vascovitz and Lisa Goodman

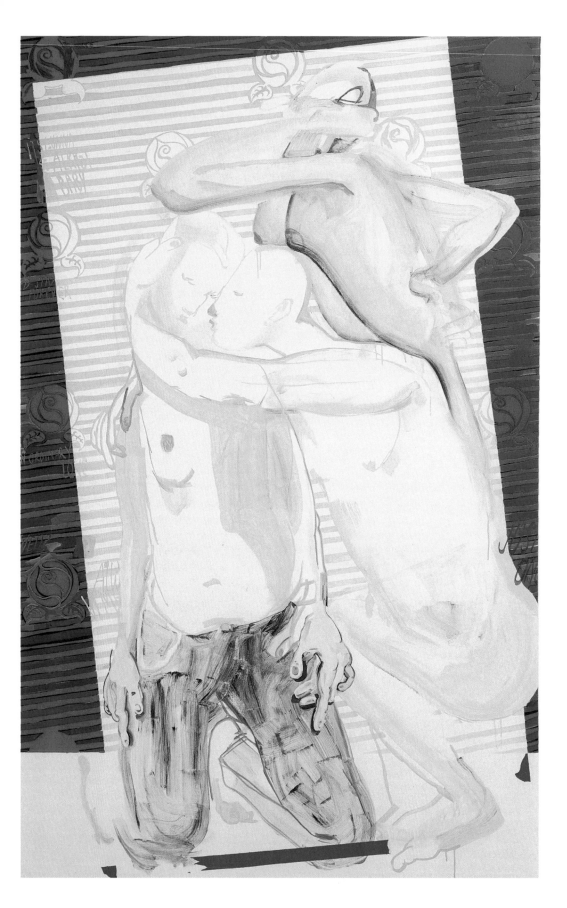

Christina Quarles, *Just Once,* 2015, 213,4 x 139,7 cm
/ 84 x 55 in., **Acryl auf Leinwand** / acrylic on canvas,
Collection of Clara and Juan Toro, Miami, FL

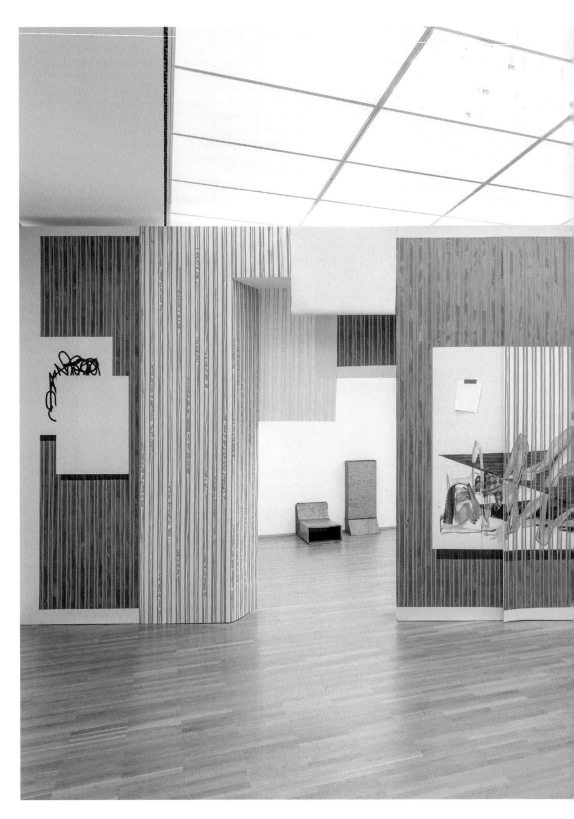

Christina Quarles, *Now We're There (And We' Only Just
Begun)*, 2023, 342,9 x 995,7 cm / 135 x 392 in., Acryl auf
Leinwand / acrylic on canvas, 6 Teile / 6 parts, Courtesy
the artist, Hauser & Wirth, and Pilar Corrias, London

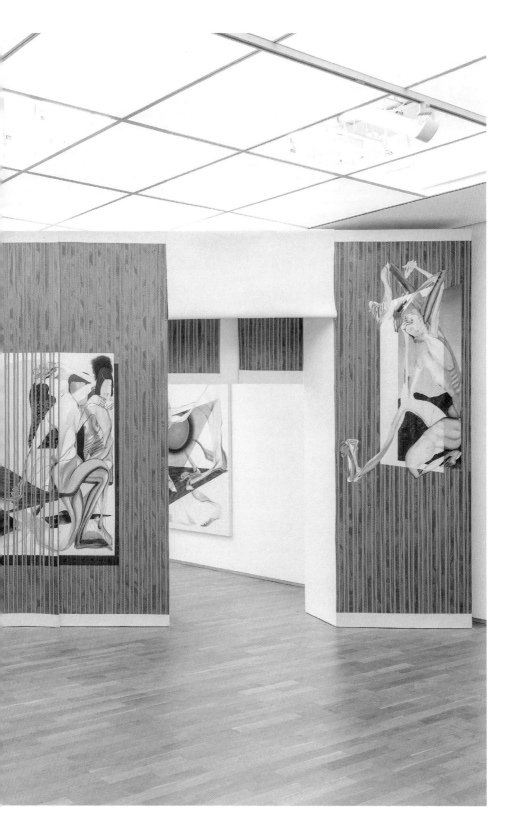

Christina Quarles

Geboren / born in Chicago, 1985
Lebt und arbeitet / lives and works
in Los Angeles

Ausbildung / Education

2016
Skowhegan School of Painting and Sculpture,
Skowhegan, ME, U.S.

2016
MFA in Painting and Printmaking, Yale University, New Haven, CT, U.S.

2007
BA in Studio Arts and Philosophy, Hampshire
College, Amherst, MA, U.S.

Ausgewählte Einzelausstellungen / *Selected Solo Exhibitions*

2023
Christina Quarles: *Collapsed Time.*
Hamburger Bahnhof – Nationalgalerie der
Gegenwart, Berlin, DE; Katalog / catalog

2021
Christina Quarles: *Dance by tha Light of tha
Moon.* X Museum, Beijing, CN
Christina Quarles. Museum of Contemporary
Art Chicago, Chicago, IL, U.S. (zweite Station
/ traveled to Frye Art Museum, Seattle, WA,
U.S.); Katalog / catalog

2019
Christina Quarles: *Every Silver Lining Has Its
Cloud.* Pond Society, Shanghai, CN
Christina Quarles: *In Likeness.* The Hepworth
Wakefield Museum, Wakefield, GB (zweite
Station / traveled to South London Gallery,
London, GB); Katalog / catalog
Yew Jumped too Deep, Yew Buried the Lead.
Richmond Center for Visual Arts, Western
Michigan University, Kalamazoo, MI, U.S.

2018
MATRIX 271/Christina Quarles. The MATRIX
Program for Contemporary Art, University of
California, Berkeley Art Museum & Pacific Film
Archive, Berkeley, CA, U.S.

Ausgewählte Gruppenausstellungen / *Selected Group Exhibitions*

2023
Dreaming of Home. Leslie Lohman Museum
of Art, New York, NY, U.S. (bevorstehend /
forthcoming)
Capturing the Moment: Painting After Photography. Tate Modern, London, UK (bevorstehend / forthcoming)
Brave New World. Museum de Fundatie,
Zwolle, NL

2022
What's Going On. The Rubell Museum DC, Washington, D.C., U.S.
Dark Light, Realism in the Age of Post Truth: Selections from the Aïshti Foundation Collection. Aïshti Foundation, Beirut, LB; Katalog / catalog
Manifesto of Fragility. Biennale de Lyon, Lyon, FR; Katalog / catalog
Put It This Way: (Re)Visions of the Hirshhorn Collection. Hirshhorn Museum, Washington, D.C., U.S.
The Milk of Dreams. La Biennale di Venezia, Venedig / Venice, IT; catalog
Not Me, Not That, Not Nothing, Either. Leslie-Lohman Museum of Art, New York, NY, U.S.
Fire Figure Fantasy: Selections from the ICA Miami's Collection. Institute of Contemporary Art Miami, Miami, FL, U.S.

2021
New Acquisitions. Louisiana Museum, Humlebaek, DK
Our Whole, Unruly Selves. San Jose Museum of Art, San Jose, CA, U.S.
Stretching the Body. Fondazione Sandretto Re Rebaudengo, Turin / Torino, IT
The Stand-Ins: Figurative Painting from the Zabludowicz Collection. Zabludowicz Collection, London, UK; Katalog / catalog
New Time: Art & Feminisms in the 21st Century. Berkeley Art Museum & Pacific Film Archive, Berkeley, CA, U.S.
Journey Through a Body. Kunsthalle Düsseldorf, Düsseldorf, DE; Katalog / catalog
Plural Possibilities & the Female Body. Henry Art Gallery, University of Washington, Seattle, WA, U.S.
Queer/Dialogue. Grinnell College Museum of Art, Grinnell, IA, U.S.

2020
My Body, My Rules. Perez Art Museum Miami, Miami, FL, U.S.

100 Drawings from Now. The Drawing Center, New York, NY, U.S.; Katalog / catalog
A Possible Horizon. De la Cruz Collection, Miami, FL, U.S.
Don't Let This Be Easy. Walker Art Center, Minneapolis, MN, U.S.
Alien vs. Citizen. Museum of Contemporary Art, Chicago, IL, U.S.
Psychic Wounds: On Art & Trauma. The Warehouse, Dallas, TX, U.S.; Katalog / catalog
Radical Figures: Painting in the New Millennium. Whitechapel Gallery, London, UK; Katalog / catalog

2019
Young, Gifted and Black: The Lumpkin-Boccuzzi Family Collection of Contemporary Art. O'Silas Gallery at Concordia College, Bronxville, NY, U.S. (weitere Stationen / traveled to Lehman College Art Gallery, The Bronx, NY; Gallery 400 at the University of Illinois, Chicago, IL; Lehigh University, Bethlehem, PA; The Manetti Shrem Museum of Art at University of California, Davis, CA); Katalog / catalog
Paint Also Known as Blood. Museum of Modern Art, Warschau / Warsaw, PL
Stonewall 50. Contemporary Art Museum, Houston, TX, U.S.; Katalog / catalog
The Foundation of the Museum: MOCA's Collection. Museum of Contemporary Art, Los Angeles, CA, U.S.
Let Me Tell You a Story. The Arts Club London, UK
Trance. Aïshti Foundation, Beirut, LB
Kiss My Genders. Hayward Gallery, London, UK; Katalog / catalog

2018
BETWEEN. Portland Art Museum, Portland, OR, U.S.; Katalog / catalog
Made in LA. Hammer Museum, Los Angeles, CA, U.S.; Katalog / catalog

2017
Still Human. Rubell Family Collection, Miami,
FL, U.S.
Trigger: Gender as a Tool and a Weapon. New
Museum, New York, NY, U.S.; Katalog / catalog
Fictions. The Studio Museum in Harlem,
New York, NY, U.S.; Katalog / catalog

2016
Reconstitution. LAXART, Los Angeles, CA, U.S.
Appetitive Torque. Eastside International,
Los Angeles, CA, U.S.
Partners. Abrons Center for the Arts,
New York, NY, U.S.

Ausgewählte Bücher und Magazine / Selected Books and Journals

Atticus, Acne Paper 17, 2022.
John Harton et al., Trance: *Albert Oehlen,*
Milan-Geneva: Skira, 2019.
Matthew Holroyd (ed.), *Death Book III: Drawing
One Last Breath,* London: Baron Books, 2022.
Suzanne Hudson, *World of Art: Contemporary
Painting,* London: Thames & Hudson, 2021.
Helen Little (ed.), *David Hockney. Moving
Focus,* London: Tate Publishing, 2021.
Tom Lutz (ed.), *Quarterly Journal No. 19:
Romance Issue,* Los Angeles Review of Books,
2018 (cover).
Phaidon Editors, *Great Women Painters,*
London: Phaidon, 2022.
Phaidon Editors, *Prime: Art's Next Generation,*
London: Phaidon, 2022.
Phaidon Editors, *Vitamin D3: Today's Best in
Contemporary Drawing,* London: Phaidon,
2021.
Merrick Daniel Pilling, *Queer and Trans
Madness: Struggles for Social Justice,* London:
Palgrave Macmillan, 2022 (cover).
Christina Quarles / W.E.B. Du Bois, *Of Our
Spiritual Strivings: Two Works Vol. 4,* London:
Afterall & Walther König Verlag, 2021.
Heidi Zuckerman, *Conversations with Artists
III,* Aspen: Aspen Art Museum, 2021.

Christina Quarles, 2022

Auszeichnungen und Stipendien / Awards, Fellowships and Grants

2019
Perez Prize, Perez Art Museum, Miami, FL, U.S.

2017
Fountainhead Residency, Miami, FL, U.S.
Emerging Artist Grant, Rema Hort Mann Foundation, New York, NY, U.S.

2015
Robert Schoelkopf Travel Fellowship, Yale University, New Haven, CT, U.S.

Lehre und andere Positionen / Teaching and Other Positions

2021
Visiting Artist Teacher, Summer Series, Anderson Ranch Arts Center, Snowmass Village, CO, U.S.

2020
Featured Artist, Summer Series, Anderson Ranch Arts Center, Snowmass Village, CO, U.S.
Visiting Artist, Paul Brach Visiting Artist Lecture Series, California Institute of the Arts, Valencia, CA, U.S.
Visiting Artist, Visiting Artist Lecture Series, University of California, Los Angeles, CA, U.S.

2019
Visiting Artist, Low-Residency Master of Fine Arts Program, School of the Art Institute, Chicago, IL, U.S.

2016
Teaching Assistant, Advanced Printmaking, Yale University, New Haven, CT, U.S.
Teaching Assistant, Graduate Printmaking: The Hybrid Form, Yale University, New Haven, CT, U.S.

2015
Lecturer, "Histories of Inheritance: Race, Queerness and Identity in the Caribbean," Yale University, New Haven, CT, U.S.
Jury Member, Painting and Printmaking Admissions Panel, Yale University, New Haven, CT, U.S.

Öffentliche Sammlungen / Public Collections

Aïshti Foundation, Beirut, Lebanon
Art Institute of Chicago, Chicago, IL, U.S.
Astrup Fearnley Museum of Modern Art, Oslo,
Norway
Berkeley Art Museum and Pacific Film Archive,
Berkeley, CA, U.S.
de la Cruz Collection, Miami, FL, U.S.
Fondazione Sandretto Re Rebaudengo, Turin,
Italy
Fosun Foundation, Shanghai, China
Hammer Museum, Los Angeles, CA, U.S.
Hirshhorn Museum, Washington, DC, U.S.
ICA Miami, Miami, FL, U.S.
K11 Kollection, Hong Kong
KADIST, Paris, France and San Francisco, CA,
U.S.
Long Museum, Shanghai, China
Longlati Foundation, Shanghai, China
Los Angeles County Museum of Art,
Los Angeles, CA, U.S.
Louisiana Museum of Modern Art,
Humlebaek, Denmark
Moderna Museet, Stockholm, Sweden
Museum of Contemporary Art, Chicago, IL, U.S.
Museum of Contemporary Art, Los Angeles,
CA, U.S.
Museum of Contemporary Art, San Diego, CA,
U.S.
Pérez Art Museum Miami, Miami, FL, U.S.
Rennie Museum, Vancouver, Canada
Rubell Museum, Miami, FL, U.S.
Solomon R. Guggenheim Museum, New York,
NY, U.S.
Start Museum, Shanghai, China
Studio Museum, Harlem, NY, U.S.
Tate, London, UK
Walker Art Center, Minneapolis, MN, U.S.
Whitney Museum of American Art, New York,
NY, U.S.
X Museum Beijing, Beijing, China
Zabludowicz Collection, London, UK

Impressum
/ Imprint

Diese Publikation erscheint anlässlich der
Ausstellung / Published on the occasion of the
exhibition **Christina Quarles. Collapsed Time**
24. März – 17. September 2023 / 24 March –
17 September 2023 im / at **Hamburger
Bahnhof – Nationalgalerie der Gegenwart,
Staatliche Museen zu Berlin**
Direktoren / Directors: **Sam Bardaouil &
Till Fellrath**
smb.museum/hbf

Ausstellung / Exhibition

Kuratoren / Curators: **Sam Bardaouil & Till Fellrath**
Kuratorische Assistenz / Assistant Curator:
Lisa Hörstmann
Sekretariat / Office: **Katrin Berendsen**
Restauratorische Betreuung / Conservation:
**Elisa Carl, Teresa Donner, Iris Masson,
Andrea Sartorius**
Registrar Staatliche Museen zu Berlin:
Susanne Anger
Sammlungsverwalter / Collection Managers:
Jörg Lange, Thomas Seewald
Kommunikation / Communication:
Fiona Geuß, Anna Nike Sohrauer
Kunstvermittlung / Mediation: **Claudia Ehgartner**
Haustechnik / Maintenance: **Gerhard Kaiser,
Garry Rogge, Stefan Gösche, Frank Wloka**
Praktikantin / Intern: **Vanessa Hennecken**

Management Studio Christina Quarles:
Kenzy El Mohandes
Ausstellungsarchitektur / Exhibition Architecture:
Sascha Schniotalla, Flat Mountain Production (F.M.P.)
Ausstellungsbau / Exhibition Construction:
LICHTblick Bühnentechnik
Art Handling: **Flat Mountain Production (F.M.P.)**
Medientechnik / Audiovisuals: **EIDOTECH**
Ausstellungsgrafik / Exhibition Graphics: **Eps51**
Produktion Ausstellungsgrafik / Production of
Exhibition Graphics: **Annette Herwegh**

Publikation / Catalogue

Für die / For the Nationalgalerie – Staatliche Museen zu
Berlin herausgegeben von / edited by **Sam Bardaouil &
Till Fellrath**
Autoren / Authors: **Sam Bardaouil, Till Fellrath,
Jillian Hernandez**
Redaktion / Editing: **Lisa Hörstmann**

Cover: Christina Quarles, *In 24 Days Tha Sun'll Set at
7pm,* 2022, 195,6 x 243,8 cm / 77 x 96 in., Acryl auf Lein-
wand / acrylic on canvas © 2023 VG Bild-Kunst, Bonn
© Christina Quarles. Courtesy the artist, Hauser &
Wirth, and Pilar Corrias, London. Photo: Thomas Barratt
// Christina Quarles, *Bless tha Nightn'gale,* Detail, 2019,
195,6 x 228,6 cm / 77 x 90 in., Acryl auf Leinwand / acry-
lic on canvas, Christen Sveaas Art Foundation © 2023
VG Bild-Kunst, Bonn © Christina Quarles. Courtesy the
artist, Hauser & Wirth, and Pilar Corrias, London

Visuelles Konzept und Design
/ Visual Concept and Design: **Eps51**
Druck und Bindung / Printing and Binding:
Tipostampa, Moncalieri
Papier / Paper: **Fedrigoni Arena White Rough**
Schriften / Fonts: **Bagoss Variable**

Silvana Editoriale

Hauptgeschäftsführer / Chief Executive: **Michele Pizzi**
Verlagsleiter / Editorial Director: **Sergio Di Stefano**
Art Director: **Giacomo Merli**
Redaktionskoordinator / Editorial Coordinator:
Natalia Grilli
Korrektoren / Copy Editors: **Mia Prucker,
Mariangela Palazzi Williams**
Produktionskoordination / Production Coordinator:
Antonio Micelli
Redaktionsassistentin / Editorial Assistant:
Giulia Mercanti
Photo Editor: **Silvia Sala**
Pressestelle. / Press Office: **Alessandra Olivari**

Erschienen bei / Published by **Silvana Editoriale S.p.A.,
Mailand** / Milano. **www.silvanaeditoriale.it**
© 2023, Silvana Editoriale

Dies ist die erste Ausgabe einer Reihe von Begleitpublikationen zu Einzelausstellungen zeitgenössischer Künstler*innen im Hamburger Bahnhof – Nationalgalerie der Gegenwart.

This is the first in a series of publications accompanying solo exhibitions of contemporary artists at Hamburger Bahnhof – Nationalgalerie der Gegenwart.

Printed in Italy
ISBN: 9788836655151

FSC
www.fsc.org
MIX
Paper
FSC® C150257

Abbildungs- verzeichnis / *Photo Credits*

Dank
/ Acknowl-
edgements

Die Ausstellung wird unterstützt
von Pilar Corrias und Hauser & Wirth.
Ein besonderer Dank gilt der Christen
Sveeas Art Foundation. / The exhibi-
tion is supported by Pilar Corrias and
Hauser & Wirth. Special thank you to
Christen Sveeas Art Foundation.

Die Publikation wurde ermöglicht
durch die Freunde der Nationalgalerie.
/ The publication was made possible
by Freunde der Nationalgalerie.